D1344437

 information **📞**01603 773114
email: tis@ccn.ac.uk

21 DAY LOAN ITEM

Please return <u>on or before</u> the last date stamped above

A fine will be charged for overdue items

 CITY COLLEGE NORWICH

203 222

OTHER TITLES IN THE SHORT CUTS SERIES

THE HORROR GENRE: FROM BEELZEBUB TO BLAIR WITCH
Paul Wells

THE STAR SYSTEM: HOLLYWOOD'S PRODUCTION OF POPULAR IDENTITIES
Paul McDonald

SCIENCE FICTION CINEMA: FROM OUTERSPACE TO CYBERSPACE
Geoff King and Tanya Krzywinska

EARLY SOVIET CINEMA: INNOVATION, IDEOLOGY AND PROPAGANDA
David Gillespie

READING HOLLYWOOD: SPACES AND MEANINGS IN AMERICAN FILM
Deborah Thomas

DISASTER MOVIES: THE CINEMA OF CATASTROPHE
Stephen Keane

THE WESTERN GENRE: FROM LORDSBURG TO BIG WHISKEY
John Saunders

PSYCHOANALYSIS AND CINEMA: THE PLAY OF SHADOWS
Vicky Lebeau

COSTUME AND CINEMA: DRESS CODES IN POPULAR FILM
Sarah Street

MISE-EN-SCÈNE: FILM STYLE AND INTERPRETATION
John Gibbs

NEW CHINESE CINEMA: CHALLENGING REPRESENTATIONS
Sheila Cornelius with Ian Haydn Smith

SCENARIO: THE CRAFT OF SCREENWRITING
Tudor Gates

ANIMATION: GENRE AND AUTHORSHIP
Paul Wells

WOMEN'S CINEMA: THE CONTESTED SCREEN
Alison Butler

BRITISH SOCIAL REALISM: FROM DOCUMENTARY TO BRIT-GRIT
Samantha Lay

FILM EDITING: THE ART OF THE EXPRESSIVE
Valerie Orpen

AVANT-GARDE FILM: FORMS, THEMES AND PASSIONS
Mike O'Pray

NEW GERMAN CINEMA: IMAGES OF A GENERATION
Julia Knight

EARLY CINEMA: FROM FACTORY GATE TO DREAM FACTORY
Simon Popple and Joe Kember

PRODUCTION DESIGN

ARCHITECTS OF THE SCREEN

JANE BARNWELL

WALLFLOWER

LONDON and NEW YORK

A Wallflower Paperback

First published in Great Britain in 2004 by Wallflower Press
4th Floor, 26 Shacklewell Lane, London E8 2EZ
www.wallflowerpress.co.uk

A catalogue record for this book is available from the British Library

ISBN 1 903364 55 8

Book Design by Rob Bowden Design

Printed in Great Britain by Antony Rowe Ltd, Chippenham, Wiltshire

CONTENTS

ACKNOWLEDGEMENTS

I would like to thank the designers Christopher Hobbs, Malcolm Thornton, Kave Quinn, Laurence Williams, Stuart Craig and Henry Harris for their time and invaluable insights into their craft.

I am also grateful both to my colleagues and students at London Metropolitan University.

Although this book represents many years of personal and professional interest including two years of research, it also owes its existence to the support and encouragement of those who debated the exciting territory of Production Design with me. In particular I would like to share this work with the following people who kept me on track during the evolution of the book: my parents Mavis and Alex, my brothers Phil and Neil, my amazing boyfriend Roberto, and inspirational friends Adele, Anwar, Sylvia, Frank, Kirstie, Des, Caroline, Nigel, Ryan, Sam, Sara, Paula, Lily and Mim.

INTRODUCTION

In writing about film and television, it can be tricky to separate out responsibility for key aspects of the production; a situation particularly true of production design which is a highly collaborative practice. There is comparatively little written on this elemental role and many of the books that do exist spend time complaining of this paucity. However, I would prefer not to frame the discussion in terms of screen design as the poor relation, electing instead to embrace it back into the family where it belongs.

The area is of course vast and can by no means be covered exhaustively here. The aim of this book is thus to provide an introduction to the subject, and a route in to closer study of particular aspects of it. I hope to make clear a way of looking at the screen image from a new perspective – that of the designer. In order to achieve these aims I will attempt to define what that perspective is and how it came to be, providing examples of the means by which it enriches the pictures we see on our screens.

This study begins with a historical overview of the role of the production designer, in the context of the evolution of the film and television industry, signposting key movements and characters that have been influential in this process. Chapter 2 considers the importance of place to design and the production as a whole. Chapter 3 is more practical in its examination of the process a designer engages in, from agreeing to undertake a project to the final edit. Chapter 4 is concerned with the temporal identity of screen imagery, examining examples from different periods in time. Chapter 5 looks at the way that technology has evolved and influenced the work of the designer.

Essentially, the production designer assists in bringing the script to life through a range of technical and creative choices. Using interviews with major designers, this book examines the role through a discussion of key films and television texts. In chapter 3 the process is illustrated from concept to finished design, using sketches, paintings and other preparatory material. The work chosen taps into different approaches and indicates traditions and trends that exist. For example, British production design is often considered to have a highly developed sense of time and place. In television, authenticity has become an issue in the many literary period drama adaptations, leading to popular misconceptions regarding the nature of design in less realist productions. Design can do much more than give assurances of time or place, contributing to the texture, mood and meaning of the work. The production designers considered here exemplify the talent and diversity that exists in the field.

Many common concerns were voiced during my discussions with contemporary designers, the most recurrent being the importance of story over personal creative ambition. This notion could well be inherited from the early days when the role of the designer was considered to be technical rather than creative; today a certain degree of invisibility is often the mark of effective design. Confusions that existed in the past over the role of the art director – and led to the creation of a new term in 1939, that of the Production Designer – will be further examined.

As sets have developed from painted backdrops to sophisticated multifaceted environments, technical advances have allowed the camera to break away from its static theatrical origins and explore spatial possibility. The evolution of the set and screen language is thus mutually entwined, each strengthening and contributing to the continued expansion of the other. In line with technical development, aesthetic approaches gathered momentum, yet two very different methods can be identified in the expressive forms from Europe and the realism of the United States, two directions which are still definitive of design today and will be closely considered.

Without a place, space or location to shoot in there is no film. Whether it is 'the portrayal of space as filtered through the emotional state of the subject' (Sennett 1994: 35) or 'the recognition of certain studio landmarks, a déjà vu that inspired familiarity' (Clarens & Corliss 1978: 72), screen design has been elemental in our minds.

1 THE ROLE OF THE PRODUCTION DESIGNER

The history of screen design and the *production designer** are inextricably linked to the evolution of film and television. This opening chapter traces the histories of these related areas of film design, personnel, and the medium in which they work, examining origins and considering the route that has lead to their present form.

The intriguing figure of the production designer will be uncovered, leading to a greater appreciation of this role in the production process, which is so often misunderstood. Partially this has been due to the nature of the role which is linked to backstage, behind-the-camera notions of concealment. However, it is also perpetuated by a fundamental lack of understanding and therefore acknowledgement by critical or popular study. I have found this to be an exciting rather than negative aspect of this enquiry, as there is the sense of an increased awareness now ripe for further discussion. The examples of past and present work included here aim to trace a path, signposting key moments, movements and players. One of the most recognisable moments is the development of the Hollywood studio system, which created a highly organised art department that was responsible for some of the most memorable iconography in cinematic history. Yet huge contributions to art direction are also acknowledged as coming from Europe as early as 1903 and later with distinct movements, including German Expressionism, Italian Neo-realism and French New Wave, all of which challenged the Hollywood hegemony.

* terms indicated with an asterisk throughout the book are defined in the Glossary

Only about 10–20 per cent of the job is about having ideas and designing. You're listing everything that needs to be researched. You're finding locations. You're hiring crew. It's essential to surround yourself with a strong team: a good art director and construction manager will take some of the responsibility off your shoulders so you don't have to spend every waking minute worrying about the money and the time you have. (in Ettedgui 1999: 63)[1]

This contemporary account of the role of production designer indicates the parameters of the job today but how did it evolve to encompass these skills and responsibilities? It has been said that the art directors of the 1920s would not recognise their contemporary counterparts, so how has the role grown and developed to become what it is today?

A brief history

In Paris, on 28 December 1895, Louis Lumière publicly unveiled his Cinematographe. His films are considered the beginning of documentary film as they recorded real events as they happened; workers leaving a factory, trains pulling into stations. There was little additional scenery, *dressing** or *props** used to embellish either the story or the style of these scenes.

In contrast, *A Trip to the Moon* (1902), by Georges Méliès, used painted backdrops and props to create a sense of place. Méliès films combined realistic and stylistic elements, which are therefore seen as the beginnings of dramatic fiction on the screen. An essential element in his films was the creation of a backdrop; these *trompe l'oeil** ranged from the everyday, such as a drawing room, to the fantastic, such as the moon.

Films were initially shot outdoors as sunlight was necessary to expose the film. Gradually an artificial space in which to shoot was developed, a glass studio where new worlds could be temporarily created. The *studio** became a controlled environment, where practical concerns like weather and light could be manipulated. In 1894 in New Jersey, Thomas Edison's company built the first dedicated film studio, the Black Maria: a shed covered in tar paper that rotated to make the most of daylight hours. Méliès subsequently built his own studio in France which was 50 by 30 feet in size and included a stage with painted *backdrops**. These early structures evolved into covered studios where artificial light replaced daylight. Initially these looked dark in comparison to the natural light of

the glass studios, but developments in lighting and the greater flexibility that this method afforded made them the practical solution to much outdoor and *location** shooting.

At this early stage the camera was stationary, which meant that the action was restricted to one *set**, where the actors remained through the course of each tableaux/*scene**. Méliès' use of *trompe l'oeil* was perfectly suited to the static camera as the viewer was kept at a constant distance from the backdrop, which meant changing *perspective** was not an issue and the artifice retained an appearance of reality.

The static camera reflects theatrical traditions in that it gives the audience a fixed position in relation to the action. It is clear that at these early stages the possibilities of the medium were not being fully explored, and the static camera was merely recreating those of another. In essence this flat, two-dimensional approach was married to the notion of a fixed perspective, as in the theatre where the audience sits in the same seat throughout the performance. This was about to change. Once the movement of the camera through space, positioned at different distances from the subjects/objects in frame, became a technical possibility, the settings had to be adapted to suit.

The exploration into the spatial possibilities of film design had thus begun and this meant that Méliès' *trompe l'oeil* would no longer be sufficient. Sets would need to be more convincing for the illusion of reality to be retained. A more three-dimensional approach was necessary for the camera to move through space otherwise a flat backdrop with scenery painted onto it would be revealed as exactly that.

Once the camera was on the move the construction of larger studio spaces that allowed the creation of more complex sets soon followed; these furnished the audience with multiple viewpoints. The multiple-room set was another device with which to further the apparent realism of the production. Thus a three-dimensional *model** with which the designer created space was becoming the norm. Edwin S. Porter's *The Great Train Robbery* (1903) combined real locations and painted backdrops. However, when cutting between them their incoherence was apparent. One way around this was to build sets outdoors – which took place around 1910 – thus furnishing them with real views from the windows, tying the interior and exterior together to create a more coherent sense of place.

Key films are now recognised as exhibiting a growing awareness of the set as a three-dimensional space and the opportunity that afforded

in strengthening the visual elements, enabling mood, character and story. Pathé led the way in modern design with their staircase and domestic interior sets from around 1903 and the films had an international influence. The detailed *film d'art* sets from 1908 created a new standard; and Italian spectacular design amplified this, building through many films to *Cabiria* (1914) which depicted ancient Carthage. *Cabiria* astonished audiences with elaborate texture created through the use of, stairways, different levels, and surface effects of marble, fresco, brick and stone, it explored and discovered new depth and perspective. In 1916, *Intolerance* and *Civilization* were two of the first American films to achieve note for sophisticated constructed settings. D.W. Griffith's *Intolerance* (designed by Walter L. Hall) featured 'Babylon' with towers 165 feet high, 'perhaps the first time the set is the subject of a scene' (Horner 1977: 14), the unprecedented grand scale of which was to be emulated in future productions.

At this point American film was essentially theatrical, while striving for greater realism. For *Birth of a Nation* (1915), it was proudly announced that the interiors were exact reproductions. At this early stage the role of the designer was not fully recognised or acknowledged and the first Griffiths film to give an art direction credit is *Way Down East* in 1920. However, *Robin Hood* (1922) and *The Thief of Baghdad* (1924) are considered America's first masterpieces of art direction (see Sennett 1994), as they began to explore the spatial potential of the setting. Influenced by the scale of *Intolerance*, enormous sets were built including a castle that ate a quarter of the budget for *Robin Hood*. These developments were partially driven by economics in that the financial opportunities of the medium were being recognised and it was thought that in order to capitalise on them the product should embody *higher production values**. A few foresighted film producers believed that more creative use of design would both give the product a greater respectability in the arts and drive up profitability.

The resulting longer format was successfully adopted. Alongside this development was the decision to spend more time and money on how the film looked, which had inevitable implications for the design. The *construction** of believable sets that would work in a practical sense, and assist in the narrative and character development, became fundamental to the cinema. The building of more and more complex sets led to the standing *back lots** that are now such an icon of film production. Sets were left in the back lot, where a bizarre mixture of periods and places would

coexist: 'The back lot became a gathering place for every stereotyped exterior setting required in the making of movies and many of these sets stood for decades, their outlines recognisable in film after film' (Thomson 1977: 14). The fascination with the back lot in popular consciousness continues to this day and is exemplified in more recent films like *The Day of the Locust* (1975) and *The Player* (1992), where we are given a privileged, behind-the-scenes tour.

These developments made cinema a far more attractive proposition for potential employees, particularly artists and architects, such as Cedric Gibbons and Robert Mallet Stevens.[2] The opportunities to design and create buildings which would be captured on film and seen by a growing audience was appealing to people who now had little interest in a painted backdrop but could see the huge creative potential of the new medium. Thus, by 1918, film design had firmly branched out from the stage design of its origins.

In Germany, *The Cabinet of Dr Caligari* (1919) signalled a break-through in film design which was highly influential in suggesting future possibilities that did not follow a realist route. Indeed architects establishing themselves in the cinema were keen to erase traces of the theatrical, artificial-looking set. In the theatre the audience can see where the set begins and ends, its artifice is highly apparent, whereas on the screen the audience is drawn in an immersed and a different relationship to the settings is created. The opportunity to create a self-contained environment which adhered to architectural principles in appearance though not in practice presented an exciting challenge to the new workforce. Thus, practical construction needs were met by increasingly specialised craftsmen, such as carpenters, plasterers and set painters. By the 1920s, film designers were looking at a wealth of opportunities and possibilities at their disposal. The theatrical flat had been superseded by the constructed set. The glass studio was now a soundstage where light could be manipulated.

Artist, architect, technician, visual director?

The term *art director** was explained in an article in *Photoplay* magazine in August 1916, which pointed out that it was the property men who had previously been responsible for the sets. There is even some debate around who the first art director was: according to Sennett (1994: 30) the first art director was Frank Wortman who was D.W. Griffiths' chief carpenter; while

Leon Barsacq claims, 'the American cinema's first real art director joined the industry in 1914 when the great theatrical designer, Wilfred Buckland, was signed by Famous Players-Lasky' (1976: 56). Buckland is also credited with the move into the studio by Perry Ferguson, who says: 'It was Buckland who brought the movies inside when he introduced artificial lighting and so revolutionised movie making' (1980: 28).

The title 'technical director' was one of the earliest credits used in the US, then 'interior decorator', only moving on to 'art director' in the 1930s. There has been confusion over the various terms describing roles within the art department and this is for a number of reasons. However the changing terms reflect the changing complexity and focus of the role over time. Firstly, the job has evolved alongside cinema and television. Secondly, the job and its responsibilities have often been undefined, leaving ambiguity. 'Artist', 'architect', 'technician', or 'visual director', are all terms that have been used to describe this person. It is not surprising then that the job description is equally ambiguous and elusive to pin down. That is not to say that there have not been attempts to raise the profile and understanding of the job. As Kathleen Foley explains:

> Until 1924 these artists worked either as independent contractors or as a part of the budding studio system. In that year, in a room at the rear of a Sunset Boulevard bistro, some 63 fashionably dressed artisans led by Menzies and Anton Grot, signed a document establishing the Cinemagundi Club, the principal purpose of which was to let the world at large know the extent of their contributions. (1989: 54)

The studio system in Hollywood saw the creation of a production line approach to film and this included the budgeting aspects. It is clear that the amount allocated to the art department is considered an indication of its importance to the overall success of the production and as this was second only to the percentage that went to the stars, their role was clearly valued: 'In a million-dollar production of the late 1930s the direct cost of the sets and related personnel accounted for 12.5 per cent of the total budget, exceeded only by the 30 per cent devoted to the salaries of the performers' (Albrecht 1986: 78).[3]

Hollywood used a system that divided responsibility between a supervising art director, who established the mood/concept, and a unit art

director, who actually carried out the design. After receiving a project from the supervising art director, the unit art director developed a design based on the script, sometimes in consultation with the director (see Affron & Jona 1995). The consultation process is quite ambiguous and has never been formalised, thus some directors have more influence in the look of the film than others and much depends on the individual director.

A studio like MGM had one supervisory art director, eight or nine unit art directors, thirty draftsmen and five or six illustrators. In British studios during the 1930s it was normal to have five productions going at once, each with thirty to forty sets, each of which was the responsibility of one art director without an assistant (see Carrick 1948).[4] According to Cedric Dawes, who worked at Elstree, they would shoot on around five sets a day, while working on drawings and dressings without draughtsmen, or set dressers. Reading these interviews, there is no mistaking the time and relentless effort involved in this process. Much has been written about the controversial role of the supervising art director in Hollywood. This is because they would often receive the credit for every film that came out of the particular studio they headed, regardless of whether they had had any creative input on a film or not. In fact their role was often more managerial in terms of assigning a unit art director to the film and approving the finished design.

> The head of the studio art department was the Supervisory Art Director. The first meeting to establish the schedule and budget would involve all the heads of the departments. The supervisor oversaw the studio's art department, which could employ as many as forty-five members. (Albrecht 1986: 78)

Cedric Gibbons in particular comes in for criticism in this respect. He was credited with almost everything that came out of MGM while he was in power (1924–56). Accounts imply that he was a flamboyant, colourful character who had strong opinions and was not afraid of confrontation. An example of this is illustrated by the situation that arose when Gibbons worked with Vincente Minelli on *Meet Me in St Louis* (1944). They could not agree on aspects of the design, engaging in a power struggle that resulted in their refusal to work together again. How much designing Gibbons did while at MGM has been hotly contested, but his strength may be identified in the distinct studio style he forged and the talented personnel he drew

into his team. He insisted on constructed sets over painted backdrops, earning him the title 'the man who put the glove on the mantelpiece' (Mandelbaum 1985: 62), something not possible if the mantelpiece was painted on canvas. Thus his architectural background informed his sensibilities when designing for the screen, ensuring a three-dimensional approach. '[E]very other studio in Hollywood followed [Gibbons'] moves, improved their art departments and worked hard on creating an individual look' (Clarens & Corliss 1978: 29).

In much of the material available, Gibbons stands out from other designers in the fact that he is described with similar interest as afforded to one of the stars. Donald Albrecht writes, 'Gibbons was a prominent figure on the Los Angeles social scene and lived as lavishly as any Hollywood star' (1986: 89) in his mansion in the Santa Monica mountains with his film star wife, Dolores del Rio. It was Gibbons who is credited with designing the Oscar statuette. His profile and star-like status is interesting in connection to the role and he certainly seems to imbue it with a visibility that is not in evidence with contemporary designers. Affron and Jona (1995) ask, was the prestige of MGM sufficient to win Gibbons so many nominations and awards? Or was it the other way around – did his celebrity bring attention to MGM's art direction? His position raises questions regarding ownership of the images created under this system, but also, in the wider context working today, the designer as auteur is a recurrent theme.

Eugene Lourie worked as an art director in Hollywood and criticised the lack of individuality that led to homogenous designs that seemed to be churned out in response to the system as a whole (see Clarens & Corliss 1978); the nature of which was a key point working against the production line of the studio system, the lack of room for fresh ideas or experimentation that could result from a 'design by numbers' approach. David Thompson has written that 'through the 30s and 40s Hollywood décor is uniform ... The rooms are air conditioned with a confidence that can only come from not being lived in' (1977: 16) and even David O. Selznick commented on the artificial nature of his studios sets.[5]

Clearly creativity is partially shaped by the question of finance: 'Budget has always been a crucial issue in the art department, if it managed to stay in budget it was allowed considerable autonomy' (Affron & Jones 1995: 16). Designers today, working on the spectrum from very low budget to apparently astronomical, are keen to point out the role of the budget in their decision-making process, and it is not always as straightforward

as might be expected. Controlling the budget effectively afforded the art department a degree of creative freedom.

In contrast to Cedric Gibbons, William Cameron Menzies worked independently of the studios on a *freelance** basis. Menzies earned only five Oscar nominations (*The Dove* (1927), *The Tempest* (1928), *The Awakening* (1928), *Alibi* (1929) and *Bulldog Drummond* (1929)), receiving awards for the first two. Menzies was not tied to a studio thus had a higher degree of creative freedom and worked on many acclaimed films. However it was not until 1940 that he was given an honorary award. He was awarded for his outstanding achievement in the use of colour for the enhancement of dramatic mood in the production of *Gone with the Wind* (1939). Menzies is considered by many within the industry to be the most influential art director in the history of American cinema, which makes this comparatively low number of awards surprising. This can be seen to be a result of the power within the studio system in terms of who is recognised and awarded. As he did not belong to a studio, Menzies made unaccredited contributions to films that were nominated and received awards in their own right.

Richard Day was another prominent designer, working under Cedric Gibbons during the 1920s, going on to freelance at United Artists during the 1930s. He was considered highly talented, frequently winning nominations and awards. The German Hans Dreier was Paramount's supervising art director until 1950 and unlike Gibbons he actively designed and shared the credit with his team. Thus, for many the art department was a place of teamwork that actually provided fabulous opportunities to learn and develop a wide variety of skills within the stability of the studio system. Many design personnel in the 1930s would undertake a variety of jobs across the art department, which allowed for talent to build across a number of disciplines and thrive, rather than confining it to one specific area of specialisation. Thus by the time someone had worked their way up to art director they could have experienced the roles of sketch artist, draughtsman, set dressing and special effects. This also had the benefit of an understanding of how the team operated as a whole, rather than as fragmented specialisms without integration.

Another positive aspect of the studios was the wealth of resources that were available. The scope of the facilities was vast and had a huge effect on the designs that came out of them. Key elements like paint and model shops were in place, which made life easier for the designers as most of

what they wished for could actually be created 'in house'. Resources like these also had implications in terms of recycling of sets, which will be discussed in more detail in further chapters. Thus, although the studio system has been criticised for making everything look the same and denying the individuality of the art department employees, it was a highly effective system with huge benefits in respect of both quantity and quality that emanated from them.

One fascinating result of the studio system was the establishment of specific and defined styles within each studio. Paramount was modern, elegant, white and predominantly art deco, Universal was gothic, MGM grand bourgeois. MGM was considered the richest and most extravagant, with dreamlike dwellings that often occupied the highest skyscraper for maximum impact: 'This MGM look evolved – with the Depression and the tapering off of Art Deco it found a slightly more moderate look while remaining firmly expensive' (Clarens & Corliss 1978: 27). Hans Drier brought some *Bauhaus** influence to Hollywood, exemplified in the films *Monte Carlo* (1930) and *Trouble in Paradise* (1932). He is one of the people responsible for the creation of the film noir look, with its strong use of shadow and key motifs of sleazy offices equipped with Venetian blinds, telephone, filing cabinet, coat-stand, and glass panelled door incomplete without a name stencilled on it.

These distinct studio styles have been read in a similar way to the construction of the star system in Hollywood. That is to say that each studio wished to differentiate their product from the others and the design was a prominent way of doing so (see McDonald 2000). Thus production design was a method of signalling to the audience something of the product of each studio; in the same way that an audience would turn up to see a film because of Jean Harlowe or Greta Garbo they might too for the latest MGM sumptuous style or the gothic delights of Universal.

Whilst the studio system in America grew from strength to strength the rise of the Nazis in the 1930s resulted in a diaspora of talent that was to prove highly influential in the cinema as large numbers of European immigrants found work in Hollywood. According to Robert Sennett, 'the greatest contribution to the history of art direction in the cinema would come directly from Europe' (1994: 30). The European artistic sensibilities created a darker and more complex look to the sterile glamour of the US sets. An example of this contribution can be identified in *Metropolis* (1926), which

was a landmark in terms of concept and technical achievement. Designed by Otto Hunte, Karl Vollbrecht and Erich Kettelhut, the film was so visually groundbreaking that its influences are still in existence today and can be identified most recently in *AI: Artificial Intelligence* (2001).

The Production Designer

These snapshots begin to articulate the iconic strength of imagery created through the studios. Yet it was as a result of the struggle over ownership of the image and finished film that David O. Selznick came up with a new title that would help clarify what the art director did, but also acknowledge the importance of their role in the production process as a whole. None of the terms associated with design were considered to have much status until 1939 when the 'production designer' was born; the term invented by Selznick to describe the work of Menzies on *Gone with the Wind*. This new title indicated an active working partnership with the director in terms of the planning of the production. In this instance Menzies had drawn a thousand highly detailed sketches for the camera to follow shot by shot, which signalled that not only had he designed what would be in the shot but he had designed the shot itself, in terms of size, angle and movement. In this close working relationship the boundaries between director and designer become blurred.

From this point on the production designer's role indicated colla-boration in the fundamental planning of the film rather than simply supplying the background for the action to take place in. Gradually, despite union objection, the art director became known as the production designer and their assistant as the art director. While the production designer was responsible for the overall design of a film, the art director managed the art department budget and schedule and supervised construction of the sets. The division of labour has largely persisted to the present day, although the distinction is sometimes blurred.

The notion that the designer designs the sets is easily grasped but that they might compose each and every angle that is consequently shot seems to encroach on the director's territory – the crossover of which exemplifies the collaborative nature of production, while indicating the potential for conflict around the negotiation of these boundaries. Stories abound where the director is directing the actors and the designer is directing the visual elements. One way in which the designer may be said to do this is through

the use of storyboards (examples of these can be seen in chapter 3). The storyboard is a shot-by-shot drawing of each proposed frame in the film. Crucially the storyboard is drawn from a particular angle and position thus representing the camera. It is a device used in order to save time and money but one of its disadvantages is that it can inhibit spontaneity during shooting.

Depending on the script every job for the designer is different and requires technical, creative and practical skills. One key decision a designer is always faced with is whether to shoot in real locations or to construct sets in the studio, a choice which is based on factors such as the size, quiet and accessibility of the real location. An existing environment has actual restrictions whereas a studio is a controlled space where most of the possible variables can be dealt with. The use of real locations is sometimes favoured for the sake of authenticity over convenience and manipulation.

This discussion does not hinge entirely on these practicalities but also represents another key stage in the development of screen design on a more deeply embedded ideological level: 'First in Italy in the late 1940s in response to the modest decorative requirements of neo realism and then with great insistence in the late 1950s during the New Wave in France, the debate rages between advocates of constructed sets and the partisans of real streets and buildings' (Affron & Jona 1995: 24). The studio was spurned as false and sterile during these movements into the street. It should also be noted here that the fact that the street became such an enticing option was partially due to innovations in technology, which resulted in more portable equipment. Many saw these moves as the possible death of the art director but in fact they increased aesthetic possibilities. Just because the location is real, this does not negate the work of the designer – issues around choice of location, composition and dressing still prevail. This contribution was recognised officially when in 1954 Hollywood awarded the Academy Award for Art Direction to *On the Waterfront*, which was shot entirely on location. One of the reasons the film was so revered was due to its authentic use of the docks to create a perfect match with the story of failed hope, betrayal and dignity.

> In the real world there is too much conflicting information – every time you pick a real location you better make sure it's saying what you want it to say and you better try to eliminate anything extraneous, because the real world is confusing, it sends out

conflicting signals all the time. So the designer's job is to simplify down to the essentials and make its meaning absolutely clear. (Stuart Craig, author interview, Windsor, 2000)

Studio settings can be used to evoke a strong message: an example are the films of Alfred Hitchcock which tend to stand in opposition to this trend, with an incredible desire to remain studio-bound, using the unnatural sterility so criticised by the neo-realists as a vital component in the creation of an environment that contributes to the visual and emotional meshing of the characters and the story.

Thus we return to the discussion at the beginning of the chapter where the work of the two pioneers of film, Lumière and Méliès, installs the choice of indoor construction (in the case of Méliès) or outdoors reality (with the work of Lumière).

From the time of the very first motion pictures at the end of the nineteenth century, the cinema has followed two paths: filming out of doors, as Louis Lumière did for *The Arrival of a Train at La Ciotat Station*, and filming in studio, like Méliès, whose work foreshadowed all future fairytale and dramatic films. (Barsacq 1976: 121)

Many designers combine these two shooting options and create a balance between studio and location (a more detailed discussion follows in chapter 2). The choice ties into a discussion on strong styles that are overtly artificial, and the equally artificial styles that are read as natural or invisible.

Possible reasons for the anonymity of the designer lie in the invisible nature of much of their work.[6] The design is there to support the overall production, not necessarily upstage it. This is also in relation to the naturalistic codes employed in the vast majority of film and television. According to Allan Starski, the designer's responsibility is to make the audience believe that the artifice they are watching is real (see Ettedgui 1999), therefore suggesting that the designer is complicit in denying their own existence in order to sustain this belief. If this is the case, can it also be possible for design to actually comment on and boost what is in the story?

German Expressionism, which began in Berlin, broke away from these codes and used the design to participate in an active way in the meaning of film: 'The portrayal of space as filtered through the emotional state of the subject and the use of abstraction and geometry to render the portrayal in two dimensions' (Sennett 1994: 35). In *The Cabinet of Dr Caligari* (1919) 33 different sets were used. The painted views, which distort the sites of the action in perspective and tip them off balance, give the sets a claustrophobic atmosphere. The artificiality of the architecture was emphasised to stress the alien, synthetic psychological world of the plot (Neumann 1997).

Caligari is the most referenced German Expressionist film but there were others, such as *Genuine* and *Golem* (both 1920). However, there does not appear to be a consistent style to Expressionist film, but rather an attitude that ties these films together which each time attempts to present a unique interpretation and can be as varied as the individuals involved. American film noir is considered as a response to Expressionism and can be recognised stylistically in the composition, lighting and use of the studio. For example, *Cat People* (1942) used beautiful abstract black and white patterns to create an atmosphere of tension and foreboding. Film noir works on the lack of an 'outside' to help promote a sense of unease, claustrophobia and even paranoia.

Another example of overt design is the musical, a genre not especially prevalent today but returning with some significance. Busby Berkeley directed all-singing, all-dancing extravaganzas with stunning design. Berkeley's designers included Richard Day and Anton Grot. However, these films were often criticised for their lack of character and plot development – essentially the visuals were the dominant element in these productions. RKO's Fred Astaire and Ginger Rogers series created sumptuous sets of art deco inspiration, which were considered more supportive of the narrative and the dances in many respects. *Moulin Rouge* (2001) created a world in which it seemed okay to sing and dance again; the setting being an extraordinary homage to the musicals of the past, with an energy, wit and visual style that brought it right up to date. The style and look of the film was a knowing nod to the highly stylised and manufactured musicals from the 1940s and 1950s with an over-the-top self-referential design.[7]

Notable exceptions to the prevailing naturalism of Ealing Studios in Britain were the films of Powell and Pressburger, including *A Matter of Life and Death* (1946), *Black Narcissus* (1947) and *The Red Shoes* (1948),

which used colour in highly expressionistic ways to produce deliciously evocative design.

There are also times when the set is more riveting than other aspects of the production – Ken Adam's work has been known to overshadow the performances in the James Bond films, for example (Sylvester 2000: 14). Blockbusters with spectacular visuals and frames full of special effects are a current genre that has been criticised for a narrative weakened by visuals that dominate (see chapter 5).

One occasion when the artifice of screen design is acknowledged is during the awards season. William Cameron Menzies received the first Academy Award ever given for art direction (1929) for *The Tempest* and for *The Dove*. From the early days, when it was termed Interior Decoration (renamed Art Direction-Set Decoration in 1947), the role of design has been recognised by an Oscar. Between the first Academy Award presentation in 1929 and that in 1960 (commonly considered 'the studio era'), only ten films won Oscars for both Best Picture and Art Direction: *Cimarron* (1931), *Cavalcade* (1934), *Gone with the Wind* (1939), *How Green Was My Valley* (1941), *Hamlet* (1948), *An American in Paris* (1951), *On the Waterfront* (1954), *Gigi* (1958), *Ben-Hur* (1959) and *The Apartment* (1960). What are the implications of this? If the role of design is to support the film narrative, character and overall mood, surely these two areas should coincide far more frequently? So how does the designer qualify for the award?

> The best achievements in set designing, with special reference to art quality, correct detail, story application and originality ... The winners are to be awarded for bending their technical skill to the collaborative effort of filmmaking as well as for the uniqueness of their vision. (in Affron & Jona 1995: 185)

The studios paid for the Oscar ceremony until 1948, when British films were gaining more prizes than they had done previously. However, despite United Artists and British-produced films winning nearly one third of the Oscars in Art Direction, they gained less than one-tenth of the Best Picture awards (Affron & Jona 1995: 188). Other influences were studio allegiances, which will have affected the voting. This is of interest because what wins affects perceptions about the role of the designer and what effective design actually is. As this is one of the few times that the designer is made visible, the question of recognition impacts all the more.

By the mid-1960s the studios had lost much of their powers and with them the consistency of look. Influences included the growth of television, more portable equipment, and neo-realist and new wave aesthetics: 'Nothing remains of the work of the great Hollywood art directors, except the fragile nitrate stock on which the films were printed and a few blueprints and plans' (Sennett 1994: 26). However, interest in the studio set design system still exists and the looks are remembered with nostalgia. In 1978 an exhibition highlighted the studio styles – 'Designed for Film: The Hollywood Art Director', at the Museum of Modern Art, New York: 'The Art of Hollywood exhibition celebrates the unsung heroes of early Hollywood, concentrating on nine of the best who ranged from scene decoration to near auterism' (Peachment 1979: 49). Work included Wilfred Buckland's ninety-foot-high castle for Fairbanks' *Robin Hood*, Ben Carre's *Dante's Inferno* (1924), and the mile-long Babylon set for *Intolerance*. And again, in the Victoria & Albert Museum in London in 1980: '[G]lide down a black and white carpeted staircase designed as the keyboard of a piano; stroll up to a cocktail bar, the kind seen in many Forties dramas' (Ferguson 1980: 27).

These exhibits articulate the iconic imagery created through the studios. It should be noted that the role of the production designer became prominent with the decline of the studio system.

The designer today

> The modern day art director must be very nearly a modern day Leonardo da Vinci in the wide range of his interests, capabilities, talents and knowledge. (Kuter 1957: 5)

Like many members of the production team, the art director of the 1920s would not recognise the production designer of today. Advances in technology have driven the art director to adapt to each new development and use it to strengthen their repertoire – the addition of sound and then colour being two major changes that were embraced (as will be discussed in chapter 5).

The production designer is now the head of the art department which means that there are many people working with them to realise the design concept. These include the art director, *props master**, buyer and maker, set dresser, construction manager, carpenters, painters, plasterers etc.

Today the majority of film-makers are freelance, which means that for each new undertaking it is necessary to start from scratch, gathering a team and resources relevant to the project. Every designer has their unique way of working but the starting point is usually the script, the budget and the schedule. These key elements will be subject to negotiation. Typically the production designer will put a case forward for more time and money to realistically achieve the requirements and implication of the script. This leads onto some initial responses in terms of mood, the look and technical requirements. The next stage is research, which involves looking at reference material and visiting possible locations – a process that can take in a diversity of areas and encompass such artefacts as photography, drawings, paintings, archives and sculpture (see chapter 3).

As we have begun to appreciate, a key consideration is whether to find real locations or build them. There are pros and cons to both of these choices but often designers prefer to build, because they can control exactly what the setting will include, whereas in existing locations there is often a conflict of imagery that can confuse and detract from the overall design concept. Many designers combine these two shooting options and create a balance between studio and location that appears seamless (a more detailed discussion follows in chapter 2). For example, the film *Léon* (1994) received much attention but its design was not greatly acknowledged. The designer Dan Weil takes this as a compliment in that the design did not draw attention to itself, seeing it as a success that people thought the film was shot on location in New York when it was actually a studio construction in Paris (see Ettedgui 1999). In choosing to create the sets for this in the studio he was able to construct his own stylised version of New York that does not scream 'studio artifice' and yet conveys his own particular version of the place without encountering the messy contradictions of the real city.

Scale drawings are made which provide *floorplans** and elevations in sufficient detail as to be constructed by the set builders. Included in these drawings are practical necessities such as the locations of doors and windows. A key difference is that the plans do not mimic those of a real location, in that the primary consideration for design is in terms of the action and the camera. The architecture may often be quite mutated; the ceiling may be lowered, the angles of the surfaces altered, the position of key rooms to others bearing no relation to the intended geography. Often big chunks of the interior will not be necessary at all, the most obvious

example being when the narrative does not include an upstairs but features a hallway and staircase that goes nowhere – until recently the homes of soap characters did not include anything beyond the stairs.

The budget is a vital element in relation to what actually appears on the screen, and the designer is adept at reading through a script and attaching a production figure to it, depending on variables like how many locations there are, how much of any one location will be seen and therefore need to be built and dressed, and so on. These decisions have far-reaching effects beyond the look of the film to the overall production process. For a designer to be considered at the top of their field they must not only exhibit talent in the design but in their use of the budget. In other words they may have fantastic ideas for the look of the production, but if they cannot manage the budget effectively these are redundant. This perhaps goes back to the days of the studio, when the supervising art director was responsible for the more managerial aspects of the job. As a result the designer needs to know where to go for everything they want on the screen at a good price. Knowledge of sources can also function in leading the design in a particular direction – for example, knowing a furniture company who can provide certain pieces at reasonable rates may result in that fashion being used above a preferred style because of the financial implications.

When Christopher Hobbs was designing the television production *Gormenghast* (2000) he used Indian furniture from a warehouse he had sourced at a fraction of the cost of the usual suppliers. In doing this, the designers give themselves a contingency for other items, for which they may have had to pay a greater sum for than initially budgeted. Thus the budget is in a constant state of flux, with the designer negotiating a degree of freedom of choice with each deal that is done. Being able to source the materials and props is equally important today as the design itself; this indicates the resourcefulness of the designer and illustrates how their design must translate in a very practical sense to be successful. During the studio era this side of the job was made far simpler by having such a huge range of resources under one roof, making external sources largely unnecessary.

The schedule is also fundamental in this planning process. The length of time given to pre-production, production and post-production impacts on how the film looks (discussed further in chapter 3). Also, the script is divided into shooting days according to location or actor availability rather than the chronological order of the script, which can mean that

sets have to be produced and turned around very quickly. Planning and organisational expertise are crucial in achieving workable sets that are ready according to the schedule.

Not only might a designer be required to invent individual buildings, spaces, cities and worlds, but also to provide them with a history, with a connection to the film's narrative, and to endow them with meaning. So the designer is in a practical sense building somewhere for the action to take place and in a creative sense making that place appropriate for the film world and the characters that will inhabit that world. A technique used by the designer is one of simplification: to achieve the mood or effect desired, key characteristics will be played up while others are toned down. This is another reason why starting from scratch is often preferable to the designer, rather than inheriting a real place that has real anomalies, that may cause confusion or conflict with the underpinning concept of the design. For example, the film representation of place in *Notting Hill* (1999) caused some controversy in terms of its highly selective portrayal, which was accused of being unrealistic in relation to both the real place and its own construction. A small example of this discrepancy is the doorway to the house of the main protagonist (played by Hugh Grant), which is painted blue with white columns on either side. The fact that the character is supposed to be a struggling bookshop owner seems to clash with the apparent grandeur of the entrance to his home. The doorway is a real location that is incongruous with the other information on the character. In eradicating all of the details that do not support and strengthen the design concept, there is a chance that the designer will go too far. A potential danger in this distillation of a place is that the end product may appear stereotypical and heavy-handed. For example, until recently redecorated, the Fowler household in the BBC1 soap *EastEnders* was stuck in the *kitchen sink** cliché of its inception; all teapot, tea cosy, sideboard and doilies.

If it is successful a set will give indications not only of time and place but also of the psychology of the characters, and in so doing offers a wealth of possible information regarding plot and narrative development. According to Leon Barsacq, 'the same interior or exterior must be treated differently according to whether the film is a drama, thriller, comedy or musical' (1976: 126). There are recognisable approaches and characteristics adopted that are driven by genre and some of these are discussed in the next chapter. In short, the designer is responsible for creating an atmosphere, and

whether of tension and anxiety or comfort and joy, it is largely through their evocation of place. Barsacq continues:

> As a general rule, airy sets with many windows or other openings give an impression of gaiety and thick walls, narrow windows and low ceilings create a heavy atmosphere ... The designer can play with height and depth, large or small scale, matte surfaces or gleaming floors, gold and mirrors with a range of dull colours or violently contrasting tones. Each combination arouses different feelings that are difficult for the spectator to analyse but of which he is nevertheless aware. (1976: 126)

So far the discussion has largely concentrated on film, but as we have increasingly seen, the production designer exists in television as well, although the role differs in some respects in relation to the technicalities of the medium and the formats produced. Television has broadened the opportunities for design through a diversity of programming. Drama productions that have similar design needs to film, coexist with game shows, news programmes and chat shows, where the audience is directly addressed and acknowledged. The job can encompass the naturalistic setting of a living room for ITV's *This Morning* to the overtly stylised arenas of modern game shows.

In television, there are more permanent staff positions as opposed to the freelance world of film, which provide a more stable framework for the art department. On a show like *EastEnders* for example, there is a series designer whose role seems to echo that of the supervising art director of old. They oversee three designers and four art directors who will be divided between each three-week block. A block typically implies one week planning, one week of lot record (exteriors), and one week of studio record. The *set up* * of *EastEnders* means that no one can work in isolation and run wild with a visual interpretation of a storyline as this would cause major continuity problems. As with most film and television, the programme is shot out of chronological order, which is one of the reasons why planning expertise is so crucial. Any mistakes that are made cause problems for those working ahead or behind that particular block.

On television shows that have established sets that are viewed every week, such as soaps and sitcoms, the designer inherits the set and any changes they like to introduce would run the risk of breaking continuity

of story or character. Thus on existing sets, dressing and some updating is usually all that is necessary. However, there are usually new sets or exteriors to work on that provide fresh opportunities – for example in *EastEnders* there are around 14 new sets a year. Another key difference in television is that it is often shot using several cameras, a fact which impacts strongly on the design. As Laurence Williams (former Series Designer of *EastEnders*) explains:

> In film you can design a four-walled set where each wall strikes out at leisure to put your camera in and relight but with this you can't do that – your set has got to be adaptable, it's got to be designed so that you've got camera traps and doors and windows in the right place so that when you've got action in that living room you can get three or four cameras looking at the same time and not see each other. (author interview, Elstree, 2000)

Conclusion

The designer may be similar to an architect, but their design and build must imbue the character and feel of the production, and project this message clearly to the audience from the first frame to the last:

> They dissolve the conventional distinction between photography (realistic) and painterly (artificial). Since the late 1920s film was seen as completing the realism of photography by adding movement. In essence they don't photograph a world they build a painting. (Durgnat 1983: 41)

The confusion around the term and the role is therefore quite appropriate in that the production designer crosses boundaries of medium and skill resulting in the hybrid that exists today which can be seen as the product of a rich inheritance. The job of the production designer is not documentary but rather dramatic representation which, while concerned with authenticity, is crucially striving for a mood or spirit rather than a photographic reconstruction.

In terms of scale, the role of the production designer can encompass the creation of a news desk or a soap sitting-room to another world or universe. The designer goes through a similar process to an architect as far

as conceiving, drawing and building; the essential difference lies in the fact that the designer's building will exist during shooting only, being struck as soon as the camera has captured what is necessary. Therefore, practicality and durability are not at the core of the design in the way that is necessary for a functional building. How this role is achieved can take many routes, and this aspect of process will be discussed further in chapter 3, where a consideration of different designers' ways of approaching and working on a project will be examined.

2 WHERE ARE WE?

Are we in a 'real' location or a constructed set? Is it recognisable, or has it been carefully crafted as to deny the audience that knowledge? Does it matter or make a difference to the story, characters or atmosphere? The designer is key to these issues and those of whether the place in question is an interior or exterior, a pub or a palace.

There has to be a place for the action to unfold in, but where can often be overlooked by an audience. However, the location impacts on the story and has implications for the characters, and therefore the creation of the setting is of fundamental importance. It is a dynamic factor, not just a stage for the actors, functioning as an interactive element of the narrative; the use of space and texture can create contrast and harmony that load the image with meaning. From the familiar environs of the Queen Vic in *EastEnders* to the elaborate and disorienting settings of *Velvet Goldmine* (1998), the production design is integral to an under-standing of the text.

The place is usually there to support the story and characters, which is one reason why it can sometimes be overlooked. However, there are occasions when the set is dominant, some of which will be examined in this chapter. Often the debate around overbearing design is that it contradicts or impedes the narrative structure; however, the spectacle of the setting can be foregrounded without detriment to the production. This is especially true in the case of certain genres where special effects are a vital ingredient.

Why are we here? Is it simply a question of finding the setting best calculated to situate the action geographically, socially and dramatically?

Certainly the effect of a love scene played by the same characters speaking the same words will vary according to whether it takes place in a gondola in Venice, on the sofa of a living room in a small town, or next to a kitchen sink (see Barsacq 1976). This chapter considers the choice of screen places and their function.

The set often operates as another character; one that does not speak but communicates through images as much or as little as it is designed to. This is a function referred to by several theorists, including Affron & Jona, who write, 'Décor becomes the narrative's organising image, a figure that stands for the narrative itself. Whether the set is a repeated figure, a persistent figure or a ubiquitous figure it is inseparable from the narrative' (1995: 158). The example used by Bart Mills (1982) is of the *Raiders of the Lost Ark* (1981) opening sequence, where Harrison Ford is faced with a series of obstacles, culminating in the huge rock that rolls with increasing momentum towards him and the audience. The example is interesting because it is so active both in its motion and the threat it poses to the character. Thus the setting here is not only another character but a major antagonist.

At the birth of cinema it was usual to have only one place where the story was situated, similar to the theatrical stage of its origins. As cinema developed, the ability to spread the story across numerous different locations opened up aesthetic possibilities which impacted on the medium as a whole. Today, it is usual to have a selection of settings in which the story unfolds. Therefore, it actually stands out when a more limited use of space is employed. For example, in *Shallow Grave* (1994) there is one key set, which is the house the three main characters share. The narrative rarely leaves this place, which is exploited to great effect by Kave Quinn, the production designer. The set provides a space that actually shifts as the dynamics do – for example the attic becomes the living room of one character, who systematically drills through sections of the house revealing holes in both the fabric of the structure and the relationship of the three inhabitants. Thus, as relations between the characters break down, their physical and spatial separation reflects this with increasing urgency.

The attic in this instance is used in the same way as staircases are often used to identify status and pivotal points in character feeling and development. The character in the attic has the high ground, in that he breaks ranks with the others over their lack of morality. Such a use of staircases is exemplified in films like *Rebecca* (1940) and *Vertigo* (1958),

where Hitchcock artfully illustrates key points in the story: 'The staircase pervades his films as a household location, a site of ordeal and a model for moral change' (Thomson 1977: 18).

The audience becomes highly familiar with the set when it is used consistently, gaining an awareness of the geography of the space, understanding how the different rooms link together. A pattern or rhythm can be built up through recognition which can be effective in itself or used to highlight a point when it is broken. In *Gosford Park* (2002) the servants work downstairs, while the guests party upstairs. It is considered a huge transgression when one character is discovered as masquerading 'in service' when in fact he is the friend, not servant, of one of the guests. His occupation of the downstairs space is seen as ridiculing both upstairs and downstairs in terms of their conformity to the restricted boundaries of their space.

Not only should the set be appropriate to the story but it should be inhabitable by the characters in that story, allowing them to function effectively within the world and parameters set out in the script. Huge amounts of information can be conveyed in the set that would take pages of dialogue to divulge. This can be factual – such as where the character lives, their relative wealth, occupation, leisure pursuits, eating habits or favourite colour – or may be emotionally charged – revealing their inner life, desires and dreams. The cute and colourful charm of Amelie's bedroom (*Amelie*, 2001) lets us into her interior world; every book, poster and cushion adds to her appeal. Seeing inside Norman Bates' motel office (*Psycho*, 1960) is not such an attractive experience; the stuffed birds that ornament the walls indicate his disturbed mental state. The props, composition and dressing of these are key in establishing place and character. Jim Clay has said, 'I learnt to dress a set with characters in mind down to who framed a picture' (in Hunningher 1993: 243).

A practical issue that always needs attention, wherever the setting, is how do the characters get in and out? There are codes to help navigate this problem; for example, an exterior shot of a street is cut with a studio interior where the action takes place and this tells the audience where they are supposed to be. The device is used more in television than film, where it can signal genre as well, because it is used a great deal in American sitcoms. The convention stems from time and money constraints, whereby it is economic to have the majority of the production shot in established sets, rather than to venture outside, which would take more time and

money. The result is a formula, with a highly distinctive look, which is often theatrical (for example *The Cosby Show*, *Cheers*, *Roseanne*, *Friends*, etc).

Designers can design sets that liberate the director from this interior/ exterior problem, which have exterior views from the windows, helping to locate the set in place and time. The US sitcom *Frasier* is an example, where the Seattle skyline is visible from the glass doors of the main character's penthouse apartment, operating as a refreshing visual cue to place. The image works as an ongoing backdrop to the story, without ever showing the exterior door through which the characters should enter and exit onto the street, the in and the out of this particular show being the lift, which gives the sense of coming and going without ever leaving the studio environs. Conversely, in some productions it is apparent when there is nothing to see out of the window because it is shot out of focus or with the curtains closed.[1]

There is an ongoing antagonism between the two traditions of the street and the studio, that began when the very first films by Lumière and Méliès were created. Their work characterised the two choices that still exist today in the outdoor films of Lumière (*The Arrival of a Train at La Ciotat Station*, 1895) and the studio creations of Méliès (*Journey to the Moon*, 1902). In both cases an environment is created to situate the narrative and the characters, and even when minimal it functions as a device of these.

Real exteriors and architecture were used to give expression in the silent period, indicating ideas both symbolically and literally. The Weimar street film was a moral tale of urban living, working through escape fantasies and eventually rejecting them. In *Die Strasse* (1923) the main character, in a bid to escape the boredom of domesticity, embarks on an adventure in the street, which signifies excitement but also danger. These are ideas based around urbanisation and modernity:

> Buildings in silent films often engulf their struggling protagonists; the *mise-en-scène* becomes the enemy ... Everything becomes semioticised because there is no other way to express inner thoughts, memories, desires and anxieties than in exteriorised form through signs. Where nobody speaks, everything speaks. (in Neumann 1977: 29)

American film noir can be seen to pick up on many of the themes thrown up in the Weimar street film, including the sinister use of real architecture and

streets. This was partially the result of German exiles working in Hollywood during the 1940s and 1950s, transposing the Weimar street film with the American gangster.

Leon Barsacq (1976) concluded that in the battle between the two traditions of street and studio, the moment real life exteriors became fashionable and feasible the future of the film set was virtually decided. He is referring to the situation in post-war Europe when Italian Neo-realism (1940s) and French New Wave (1950s) criticised the artifice of constructed studio sets and advocated the use of real locations. The studio was spurned as false and sterile, the real locations being authentic and energetic in contrast. Technological advances made this aesthetic choice possible in many ways through more lightweight equipment which could be removed from the studio with relative ease, broadening horizons.

However, this move outdoors did not result in the death of the designer, and as we have seen, in 1954 the Oscar for best Art Direction went to a film shot entirely on location, *On the Waterfront*. The award was an indication and recognition of the fact that even in locations design choices have to be made. Actually choosing the location is in no way an arbitrary task, as the places chosen will be loaded with meaning. Selecting exactly what to include, taking into account the action, dialogue and the look, is the next stage. What to take away or add to this real place can be transformational. For example, *Mad Max* (1979) used an abundance of real exteriors but imbued them with a distinctive look and feel. This was achieved through the choice of particularly desolate landscapes and the addition of key dressing that signalled waste and destruction. The burnt-out car on the beach functions as an icon of a world where nothing new is created, leaving objects that no longer fulfil their original function to be either recycled or trashed. Adding to this is the litter that is strewn through the shots, indicating the breakdown of society into a state of disorder and chaos. Thus an existing location has been taken and transformed to provide visual, thematic and narrative impact.

The grammar of streets, squares, towers and derelict buildings that loomed over or closed in on the protagonist as they tried to escape their fate (as seen earlier in *The Weimer Street Film*) can be seen repeated through to today. *Don't Look Now* (1973) used the architecture of Venice to create a sense of being lost; the characters of Donald Sutherland and Julie Christie were unable to find their way home metaphorically. In contrast

to the creation of a familiar place which the audience can navigate its way around with ease, the narrow alleyways converge and disorientate, and every street looks the same. With an increasing sense of panic the architecture is used to isolate and alienate.

The choice to use a real exterior, then, can have huge benefits. There are times though when the limitations of the real can hamper the intended meaning and mood of the film. Of *The English Patient* (1996), for example, Stuart Craig says:

> There's no shot in the movie of the monastery that she takes the English patient to and there is no satisfactory exterior monastery. You don't ever see it and understand it; there is no icon for it and that's a lack. The monastery we actually shot in was too big and we were all scared of revealing its enormity, so we ended up not revealing it at all. (author interview, Windsor, 2000)

Essentially, the downside of working with a real exterior, aesthetically speaking, is that the designer is working with what is already there, rather than custom-building for the script.

In 1961 *Breakfast at Tiffany's* combined the use of the real New York City and a more stylised filmic representation. Cinematic images of cities are always selective and it is this process that helps convey the concepts of the film. Thus, calling into question the idea that using real places is somehow purer or more authentic than constructing sets, as both approaches involve a selection and combination process, this seems over simplistic. Rome, for example, has been presented in divergent ways in cinema; from the dreary Rome of the Neo-realists to the vibrant and sordid city presented in Federico Fellini's *La Dolce Vita* (1960) which has been identified as a key transitional film in the cinematic representation of the city, portraying wild hedonistic characters against ancient architecture. So, Rome: a glamorous, fashionable and exciting place, or a poor, depressed wasteland?

Similarly, real cities have a history that alters how we see them. In Rome, Fascist architecture that had been considered abhorrent by many was gradually found more palatable as time separated it from its original meaning. As Geoffrey Macnab writes, 'Venice, along with its masked balls, labyrinthine streets and waterways and a cultural tradition encompassing everything from Renaissance art to Thomas Mann and Nic Roeg, it has a darker underbelly. It's a place where corruption and violence, hedonism

and torture used to go hand in hand' (2002: 46). Thus illustrating the range of sources that may influence our perception of place. A further example can be seen in the Manhattan skyline, so familiar through cinema, and which was dramatically altered on 11 September 2001. No audience can fail to acknowledge this when faced with a pre- or post-event representation of the city.

In Britain, crime cinema, which had been called formulaic and stifled, was given a new lease of life in the 1960s through the use of real locations. The urban landscape was utilised in different ways. In the case of kitchen sink dramas, back to back terraces and factories created a poetic realism, while crime films might contrast the seedy glitz of Soho with empty warehouses and shopping centres (see Chibnall 1999; Lay 2002). London on screen is highly recognisable by a number of overused landmarks: Big Ben, Tower Bridge, Buckingham Palace, Trafalgar Square, and the ubiquitous red bus. Hugo Luczyc-Wyhowski designed *Nil By Mouth* (1998) and used the streets of Deptford in London to generate the necessary social realism: 'I don't mean authentic in the manner of a precise period evocation, or even in the grimly determinate mode of British kitchen sink realism but in the sense of it being an experience of a believable life in the cinema' (in James 1997: 6). The film-makers achieved this through adhering to a set of rules, such as the exclusion of trees and sunshine from any shot. The result has a profound effect in conjuring up the sense of a run-down area of a city that seems composed of an endless supply of dull and lifeless fabrics such as concrete. The lack of greenery exaggerates the notion of a sterile, manmade world without beauty or nature. Council blocks with long corridors promote this sense further, of an inhospitable world without relief. The portrayal of housing may also be read as a sign that the high-rise dreams of modernism are decaying and instead of a utopia they are crime-ridden infestations of hopelessness.

For *Get Carter* (1971) the setting of the original novel, a small town near Doncaster, was changed to Newcastle for the screen because the look and feel of the city provided a stronger image. The film now seems synonymous with the place, having presented a powerful iconography of the North of England. However, these images were criticised for making the sordid decorative (Murphy 1999: 123). Newcastle was used again in *Stormy Monday* (1987): 'This is a Newcastle of retro-noir, with Hopper colour and a jazz soundtrack' (Brunsdon 1999: 156). Charlotte Brunsdon discusses the personal use of space in the representation of both key

characters, played by Sean Bean and Melanie Griffiths, who are in the same city, yet the design of each suggests difference. These characters occupy different worlds and this is skilfully illustrated in the design of each of their habitats. Bean looks out of the window to the river Tyne, framed by a rotten, decaying window sill, while Griffiths is enveloped in the soft white and peach light of her plush hotel room. Thus cities have been depicted and cast to fulfil every expectation from foul, dirty and degenerate, to glamorous, shiny wonderland. The city has been used as a symbol of hopelessness and a place of promise and adventure: 'There is a Paramount Paris and MGM Paris and RKO Paris and Universal Paris and of course the real Paris – but Paramount Paris was the most Parisian of them all' (Sylvester 2000: 45).

Why and how is it that Paramount Paris appears more Parisian than the city itself? There is the perpetuation of imagery that impresses upon the audience a degree of authenticity not present in the real version because the real city contains lots of anomalies and contradictions whereas the highly constructed version distils the essence. David Sylvester explains:

There is something about the medium of film that enables it to implant images in the mind that are more real than the real world; to stage manage our perception of the facts of everyday life. Southern Plantation houses look like Tara; airports look like the last scene of *Casablanca*; motels look like the Bates motel. (ibid.)

In considering this transformation of the 'external real', Bart Mills states that, 'the highest refinement of the production designer's art is to bring the outdoors inside' (1982: 42). Mills clearly feels that the artifice of the studio is a major achievement in screen design. The outdoors has been created indoors since the beginnings of cinema, so why is it that Mills gives it such attention? The studios initially shot exteriors inside, moving outside to real locations when it became technically possible. The move back into the studio is different now because of advances in technology that present exciting new options (see chapter 5). The elaborate constructions are also a distinguishing factor between film and television, with film having the scale to create visuals not possible or practical for television: 'In the studio, everything directors need, from people to plots, is at their fingertips and the right lighting is available at the flick of a few switches' (1982: 42). This point, already discussed in relation to interiors, has even greater

impact when measured against the elements involved in an exterior. The inconvenience of weather, temperature, noise, changing light and crowd control, together with providing catering, accommodation, bathroom and changing facilities for cast and crew should not be underestimated. These practical factors, together with more aesthetic ones relating to what is taken away or hidden and what is added to the location, can be viewed as negative and very plausible reasons to decide to stay indoors.

> Fox had a main street that changed less than any other street in America ... The back lot became a gathering place for every stereotyped exterior setting required in the making of movies and many of these sets stood for decades, their outlines recognisable in film after film. (Thomson 1977: 14)

The fascination with the back lot is seen in films like *The Day of the Locust*, *The Player* and *Get Shorty* (1995), where sets of a western saloon stand side by side with mud huts, pyramids, colossal statues of the ancient world, the Eiffel Tower and Big Ben, often peppered with a flock of feathered showgirls or a battalion of uniformed soldiers. The backstage scene is fascinating on many levels but potentially of most interest because it acknowledges the artifice of the screen; it shows the seams, which is pleasurable for the postmodern audience.

Studio construction also allows the creation of other worlds of a stylised or futuristic nature. *Black Narcissus* (1947) was shot in a British studio. The breathtaking settings of the convent on the mountain tops (Nanga Parbat and Mount Everest) was entirely constructed. *An American in Paris* has a sequence based on the Impressionist painters. Ten works are recreated as settings (designed by Irene Scharaff) that are recognisable from the original paintings and then spring to life. Thus, a moment is expanded and perspective provided in the before and after of the image (*Caravaggio* (1986) employs similar techniques).

As we have seen, the art of illusion has been stretched beyond its initial stage mechanics to embrace actual feelings and experiences. Jon Dowding has written that 'it is apparent that these early art directors and designers were not copying the world around them' (1982: 27), yet it is interesting to see film-makers more recently trying to recreate the artificiality so disdained by movements like Neo-realism and the New Wave. For example, Martin Scorsese, Woody Allen and Francis Ford Coppola have all made films that

celebrate the overtly constructed nature of cinema design of earlier eras, thus establishing a retro look, nostalgic of a place that perhaps only ever existed on the screen. *The Hudsucker Proxy* (1994) is another example of a representation of a New York of the past, with buildings and a skyline that deliberately reference cinematic iconography. *New York, New York* (1977) recreates 1940s/1950s cinema in its not-quite-rightness; not read as realistic due to details like inaccurate dimensions of kerbs. These screen versions of New York can seem far more attractive than the real contemporary one. Their view of New York mythologises its pre-1960s incarnation (perhaps the last time there seemed to be a cohesion to the city and a hope for its future (see Neumann 1997)). And according to Nigel Andrews, 'the childhood prologue to Scorsese's *Alice Doesn't Live Here Anymore* (1974) was a mauve-filtered studio-built countryside. Scorsese says it harks back to *Duel in the Sun* (1946), *East of Eden* (1955) *and The Wizard of Oz*' (1939) (1985: 13).

The heritage of the Weimar street film is clear in Fritz Lang's *Metropolis*, which he took out of the street and placed firmly in the studio. *Metropolis* created an urban vision of the future, which was visually stunning and influential in terms of both the ideas and the look. Lang saw the New York skyline for the first time in 1924 and was so captivated by the skyscrapers that he based much of the cityscape imagery in *Metropolis* on them. The world of *Metropolis* is layered according to social status with the underground area inhabited by the underclass workers, and above the high-rise buildings with the New Tower of Babel in the centre. The science fiction writer H.G. Wells criticised the realism of this future vision, claiming that cities would build outwards rather than upwards. However, the visual and social stratification was so effective that Wells' comments appear insignificant.

The far-reaching influence of this film can be identified in films such as *Blade Runner* (1982) and *Batman* (1989), where similarly fantastic cityscapes were created using studio composites. *Blade Runner*'s fusion of Frank Lloyd Wright architecture, *Metropolis*, Tokyo and Las Vegas, created a cyberpunk aesthetic that then influenced the look of music videos, television commercials, feature films and nightclubs (see Neumann 1997). A similar logic was applied to that of *Metropolis* in that the classes would be very visibly segregated. The streets would be populated by an exotic underclass, while anyone with any means would live in skyscrapers or in orbit. The decay and neglect of the city was symbolised by the 'retrofitting'

of buildings, which created strange shapes and juxtapositions of style. This incredible city came into existence as a composite of 27 separately filmed elements.the postmodern mix of architectural styles is echoed in that many of the buildings used were recycled from existing studio settings of previous films, including *The Way We Were* (1973), *Funny Lady* (1975) and many Warner Bros. films. Further reference to places we have already visited on the screen come in the form of night shooting, associated with film noir of the 1940s. The building of layers of texture created a highly detailed *mise-en-scène**, where the image is overloaded to tie in with the notion of information overload.

As initially discussed in chapter 1, exteriors and interiors are usually blended as appropriate to the production. However, choices can also be made to deliberately subvert audience expectations and so highlight certain concepts. For example, a total lack of exteriors can create a highly claustrophobic feeling, conveying notions relating to the characters' interior worlds, where they may be unable to extricate themselves from a particular situation. The warehouse scene in *Reservoir Dogs* (1991) functions in this way; the viewer is trapped along with the characters in the film. When Chris Penn's character leaves the warehouse, the audience get a glimpse of the world outside but the door shuts behind him. Sound design supports this concept in that there is a lack of exterior sound at all of the points when it would be present in a more naturalistic production. In its use of sound design, the film therefore employs reference to the past where films were either deliberately studio-bound stylistically or the special effects employed were so basic as to be blatantly apparent.

In *Edward II* (1991) Christopher Hobbs constructed a series of plaster caves on wheels where almost the entire film took place. The caves were left quite bare but punctuated with key props, such as the throne or a dining table. The design conveys a sense of the world of the characters, who were caught in the labyrinth of court intrigue and betrayal. Conversely, when an individual is banished he is seen in a hostile environment in the midst of a storm, which plays with the notion that the court claustrophobia may also provide a protective function in sheltering characters from reality.

The landscape has provided significant design opportunities from the desert in *The Sheltering Sky* (1990) to the use of the countryside as a contrast to the city streets in film noir. In *The Hustler* (1961), nature features once in the whole film. The subterranean world of pool halls, bars and bus terminals is Paul Newman's natural habitat. The one glimpse of

nature is when he shares a picnic with his girlfriend on a grassy verge, a pivotal point as she reveals her love for him. The use of the rural landscape is used sparingly to convey character and narrative in simplicity.

In *The English Patient*, the affair between the two main characters develops in the desert, an extreme in terms of climate and terrain, which accentuates the passion of the relationship. Similarly when Ralph Fiennes leaves the injured Kirstin Scott Thomas to go for help, it is in a cave. The rock provides shelter from the elements but no light, which is a very deliberate metaphor regarding their relationship and the future events. That is to say, their affair has not existed in the public realm and the setting indicates that it is not possible for it to do so.

In *A Life Less Ordinary* (1997), the romantic couple run away to a log cabin. This functions as a highly secluded area where it is difficult to be detected, one which also crucially nurtures their budding relationship. The choice of setting is natural, stripped down, back to basics, suggesting something elemental about their feelings for each other. Coming from two different worlds, they find themselves in a neutral setting, free from the trappings that would usually confuse or divert.

That is not to say that a natural, outdoor setting implies a beautiful, positive environment. Nature can be used with equal complexity to convey cruelty, violence, confusion and chaos. Consider disaster films or storms at sea (see Keane 2001), isolation on inhospitable islands, the terror of the beach scene in *Suddenly Last Summer* (1959), or the woods and forests so iconic of horror film and used to convey increasing despair so effectively in *The Blair Witch Project* (1999) (see Wells 2000). Once the setting is chosen it is often difficult to imagine the scene taking place anywhere else. Such is the power of the visual, anchoring the viewer's understanding.

Real interiors are sometimes used because of either cost or authenticity, but they do create problems in terms of space and therefore shooting options, sound and – as already mentioned – the confusing iconography that exists in most real places. A good example of the use of real interiors is *Trainspotting* (1996) which includes a pub and a hotel room. In both instances the interiors were in keeping with the overall design, even providing added interest in the case of the hotel room, which was circular. Both of the locations were almost completely repainted in order to tie in with the colour palette of the rest of the film and the combination used in this instance illustrates how constructed and existing interiors can work

together to strengthen the overall design motif. By working with what is there and enhancing it, instead of trying to disguise and pretend it is something other than it is, real interiors can be stylistic assets.

In *Jubilee* (1978), for example, the primary location was a disused warehouse painted black, and the very lack of other settings and props helps convey key ideas in the film. It is a punk world, where mainstream ideology is rejected. By stripping down the settings the audience becomes involved on an aesthetic level, as there is no comfortable naturalism or normality to find – even the garden is constructed from plastic; this is undeniably intriguing visually but the comment it makes is stronger still in terms of sterility and lack of life. The weeds have gone but so have the flowers and the creatures that lived on and off them.

It is true that the distinctive looks associated with the studio have diversified since the 1950s and 1960s. David Thomson writes that 'the abandonment of the studio has dissipated the iconography of design' (1977: 13), yet there always remain identifiable styles. There is an interesting iconography in low-budget British films currently where real interiors are used because the project is being produced on such a small scale. The result produces such distinctive looks due to the limitations on where the camera can shoot the action from – the fourth wall cannot be conveniently removed. In addition, the same interior is sometimes revamped and redressed to create a sitting room, office, shop, and so forth. This gives a kind of coherence to the overall design that can be hugely effective, creating a déjà vu reminiscent of the studio systems' recycling parts of sets.

When an interior is constructed it can have far greater flexibility and what is seen on the screen can bare little resemblance to the construction. For example, the illusion of a real interior with four walls and a ceiling may be preserved when in fact there are only two walls and no ceiling. Lawrence G. Paull, who art directed *Blade Runner*, said, 'I always try very hard to make the sets look unlike sets but like environments where the actors can do their business' (in Turner 1987: 56). The constructed set often denies its own artifice, which is one of the reasons the Neo-realist and New Wave movements denied its usefulness to their agendas. However there are many examples where the artifice has been celebrated. In German Expressionism, the setting became highly stylised, bearing no relation to real places, but intercepting perception and visualising a mental, emotional response to space. These places exist in the mind and in an

individual interpretation of the world that challenged attempts to construct the 'real world', preferring to take the artifice of constructed sets to a new level, where they blatantly commented on the events within the narrative. The lines of vertical and horizontal planes clash, playing with the rules of perspective, disorientating the viewer and forcing a closer reading of character and story.

Even sets that appear realistic usually contain some element of stylisation; in *Notting Hill*, for example, there were four main sets built – the main character's apartment, his bookshop, the restaurant and the friend's house – which represent about 75 per cent of the film. How does this comparatively limited range of settings affect the film? This signals that of course the characters have been elsewhere but these locations are very firmly the focus of their world. A key motif in the film is the close circle of friends, so the limiting of locations echoes this idea and makes Julia Roberts' puncturing of it all the more dramatic. The Italian restaurant in *EastEnders*, although heavily researched, was adapted to suit television. For example the restaurants in reality had white walls with some pictures hung upon them. The look translates as stark on the screen so the construction, although based in reality, again chose which elements to retain and discard. The decision is partially based on a technical issue to do with white sets not photographing very well, but also an aesthetic one. The designer wanted the restaurant to have an inviting look and atmosphere, so painted the walls a warm yellow, as opposed to the white observed in research.

In soaps the sets become as familiar as the characters, with the audience returning each week to a set that spatialises family and community. In *EastEnders* the only excursions are day trips, or holidays, which are comparatively rare occurrences. Events in *EastEnders* are in relation to the main set, which is highly recognisable to the audience, positioned in the place in a similar way to the characters themselves, through the use of camera angles and choices of which rooms are seen (bedrooms were never seen in the past although this is changing). Familiarity is a particular strength of television, which returns to the same locations week after week, whereas film only has a limited time (about two hours) to achieve the same effect.

The everyday mundane settings of *EastEnders* help to characterise themes of work, routine, and to some extent drudgery, in the form of the launderette, the café, the pub, the fish and chip shop, the car lot, and so

on. These are all places of work, none of which inspire careers in their particular fields. These settings operate on the social and dramatic levels discussed by Leon Barsacq, in that they are places of interaction between the characters who live and work there. The storylines that unfold in these places revolve around struggles over money, work and relationships that would be given a different mood and context if they took place in more exciting or glamorous settings. Albert Square is a regular sight for contemplation and soul-searching that does not seem possible anywhere else in the programme. This is a visual metaphor that works on several levels: firstly it is located centrally, so geographically it is a connection point between all of the characters living around it; secondly it is a small section of greenery and peace in the midst of an otherwise concrete urban environment, and as such it is a refuge both physically and emotionally.

The dimensions of the set reflect those of the narrative, creating a sense of community but also a limited horizon, which may be more constricting and claustrophobic than comforting. This could be viewed as an example of what Affron and Jona (1995) call a literal and ideological impasse. There is rarely a broader view of London provided in *EastEnders*; the main clue to location is the opening credits which give an aerial view of the city. The lack of such a broader view may be due to budget constraints but it also has a direct effect on the narrative. The viewer, like the inhabitants, are contained in Albert Square and rarely get sight of a horizon line, which has a direct impact on the feel and look of the drama. Height is also an effective element in design, where the level of elevation can be used to indicate social and economic status of character. There is often a shot of Peggy Mitchell looking down from the Queen Vic onto the rest of the square – she is positioned as the Queen of the castle. The tube station, mostly shot at ground level, serves as a gateway out of this place.

EastEnders is a good example of a set being built to reflect a real location in that it is a fictional place representing a real place in the East End of London. The design of Albert Square was methodically researched to ensure authenticity – it is a replica of a real square located in London's East End. In terms of realism the scale is wrong, partially due to limited space on the back lot, which can create inconsistencies and problems, according to Laurence Williams, who says it has always reminded him of a medieval village (author interview, Elstree, 2000). There is certainly a village mentality as the rest of London is rarely seen, thus fragmenting it from the wider environment.

The design of *EastEnders* has changed in quite subtle ways since it first appeared on the screen. Originally, there was a deliberately deprived look, which translated into dirtying down paintwork, using dull colours and old-fashioned styles. Today the design is far more diverse than to suggest that everyone in the place has threadbare furniture of a floral nature. Is this a realistic endeavour or an aesthetic one?

Leon Barsacq states that the interior or exterior must be treated differently depending on whether the film is a drama, thriller, comedy or musical (1976: 126). In other words he sees very definite visual styles being appropriate to different genres. Is this inhibiting or helpful to the creative process? Before even setting foot in the cinema, the genre rouses expectations of the style and locations of any given film. For example, in the science fiction genre there are expectations of space, otherworldly and non-naturalistic settings. Westerns too have a very particular design vocabulary. This includes the town, the bank, the sheriff's office, the saloon and the landscape itself, again developing a design iconography, partially due to practical considerations like the fact that these sets were built and stored for many years, being adapted as and when necessary (Barsacq 1976: 21). However, these conventions can be played with to create interesting and challenging images. For example, and as Geoff King and Tanya Krzywinska state, the city is a prime target for disaster, especially New York and Los Angeles: 'the eruption of disaster destroys the excessive products of humanity and creates a space of heightened engagement' (2000: 146). Hitchcock also often preferred to alienate people from their settings. Thus the set can tell us about the character, not just through the objects, style of the place and so on, but whether the characters are comfortable in their environment or not. Back projection was a key technique employed here, making apparent the gap between the character and their setting.

> Since film uses the real world as its material and therefore uses objects with which one is often familiar, certain things have to be overstated, otherwise they would not be recognised as part of the drama ... the settings should be directed with as much conviction as the actors. (Dowding 1982: 93)

Yet how far does place imply narrative and genre? Let us consider the use of some familiar settings in relation to the work, play and home environment.

During the 1920s, 1930s and 1940s the office was often portrayed as a streamlined, sleek social whirl, a place of dynamic exchange and screwball comedy (for example *His Girl Friday* (1940)). The office in the 1980s film *Working Girl* (1988) is functional yet personalised through the use of props on and around the secretaries' individual desks that domesticate the working environment. The office today is often a sterile space, filled with fluorescent lighting and such mundane accoutrements as coffee machines, computers and cheap prints on the otherwise empty walls, epitomised in Neo's workplace in *The Matrix* (1999). American sitcom *Ally McBeal* is situated in a lawyers' firm: the office is the main setting (Ally's apartment and the bar being the only other key settings) and as such it functions as the work space but also as the sight of major social interaction and the obligatory internal turmoil of the main characters. The design is glamorous and modern, with huge windows and exposed brickwork. Ally's office is dominated by an enormous desk; her backdrop is the city skyline. Thus she is part of a prestigious company and yet portrayed as vulnerable and insecure. The design could easily have dwarfed and made her look out of place but instead she is woven into the fabric of the design which is sleek without being sterile or bland.

The nightclub is another stock setting: the home of Fred and Ginger in the 1920s and 1930s, through to John Travolta (*Saturday Night Fever* (1977)), and Sharon Stone (*Basic Instinct* (1992)) and Ewan McGregor (*Trainspotting*) in the 1990s. The disco functions as the ultimate in escapist location – dancing, drinking, drug taking and sexual encounters all take place here. The story takes us there to encounter love, romance and excitement, but also fear, violence and death. It is notoriously difficult to convey the energy and atmosphere of a nightclub, although *24 Hour Party People* (2002) recently succeeded in bringing to the screen something of the legend of the Hacienda in Manchester. Steve Chibnall (1999) talks about changes in British law which created shifts in terms of where criminal activity took place. For example, the Street Offences Act (1959) resulted in prostitution in clubland rather than on the streets. Therefore the recurring setting of clubs as a place for cinematic criminal activity is born of reality.

The hotel as typical setting is another perfect opportunity to put people who would not usually meet together, whether in the opulence of *Grand Hotel* (1932) or the dinginess of *Barton Fink* (1991). Mike Figgis' film, *Hotel* (2001), is set in a hotel in Venice, the scene of a conspiracy involving a

film crew staying there and the staff who are vampires. The hotel is the ideal setting for such shenanigans as where else could such a plot unfold? Thus the place enables the narrative and is essential to it. The hotel in *The Shining* (1980) is actually seen to influence and change character in a terrifying collision of past and present visitors.

Many soaps, sitcoms and films use pubs or bars as meeting places, where everyone who lives in the vicinity goes for a drink, a chat or a fight. This is a further way of getting several characters in the same place for the purposes of narrative development. As a result the pub represents mythic notions of community. Consider the cosy, inviting atmosphere created by the use of pubs in *Lock, Stock and Two Smoking Barrels* (1998), *Minder, Only Fools and Horses* and *Cheers*.

The home constitutes perhaps the most important setting in the history of narrative. David Thomson writes, 'In the space of thirty years, the art departments made an enormous contribution to the American movie. Consider how far our notion of a desirable kitchen, bedroom, or lounge was affected by their reiterated house styles' (1977: 16). From Tara in *Gone with the Wind* to *Gosford Park*, houses have actively participated in the narrative. In *The Servant* (1963), the house is slowly transformed and given a makeover by the new servant. This physical appropriation of space is a visible indication of the take-over bid on a more holistic level. The house does not stabilise there but degenerates back into disorder. In *Rebecca,* Manderley seems imbued with the ghost of the first Mrs de Winter to the point that it actually is her. In *Psycho*, the modern motel and the Gothic house combine in an image of screen schizophrenia; the new façade with the old reality lurking in the background represent Norman Bates' two realities in an image of genius. The silhouette of which has been repeated in *Batman* and was appropriated from James Stewart's house in *Harvey* (1950) originally.

Richard Sylbert talks about 'getting back home' in design, 'That's the way Mozart structured music. You always went back home ... Now home and getting back home are very serious ideas in American sensibilities ... there is something satisfying about getting back home. It satisfies the mind and it closes the circle' (1989: 22). Home is a strong idea with connotations of safety, stability, sanctuary, privacy, comfort and anywhere that has such powerful meaning attached to it can be subverted or harnessed to different ends. In *Last Tango in Paris* (1972) (whose designer was Ferdinando Scarfiotti) the underpinning idea was of an animal existence, which was

visualised in the use of flesh tones in the interiors, including colours that were intentionally uterine. The *Hammer House of Horror* series and *The House* explored fears attached to danger in the home to the extent of it having a personality of its own. Norman Reynolds states, 'Your design must enhance the mood of a scene or else it's worthless. The set is like a third actor' (in Mills 1982: 40). The point about someone's home is that it can tell us a great deal about that character. Thus the designer needs as much information as possible to create a setting that works in the context of the story.

In *The Money Pit* (1985), the house is a metaphor for Tom Hanks' and Shelley Long's changing relationship, so it is important to shoot sequentially as the house disintegrates and then rehabilitates and changes (Clarens & Corliss 1986: 4). *Rear Window* (1954) plays with the private space of the home. The main character looks into his neighbours' windows and gleans information about them in much the same way as the cinema audience. The characters seem enclosed by the frame of the window and there is a limit to what we can see or learn about them through this frame. A highly constructed and artificial sense of home was created in the film, which has been referenced greatly since. *About a Boy* (2002) features a luxury bachelor pad owned by Hugh Grant's character, which has caused critics to take exception with the realism of the design. The loft-style apartment was built on the soundstages of Shepperton and was at the core of the complaint: 'In the never-never land of film, the single male lives in designer glory, all exposed brick, chrome fittings and wood floors' (Williams 2002: 69). This screen rendition of the wealthy bachelor abode is criticised for being entirely unfounded in reality, existing only as a cinematic cliché. The point is that the set is telling us in simple screen language about the Grant character, arguably more effectively than a more realistic design, which would by nature give him a more human quality at the beginning thus giving him less distance to travel in the narrative. We see a huge loft-style apartment, tastefully decorated, empty of clutter or any indications of fluffy edges on his character. It is minimal, expensive and soulless. Thus we are given information that frames the key character – he is wealthy and lives in a place inhabited by his book and music collection more than by himself. Nevertheless, this example demonstrates again that M.J. Morahan's description of 'the two trends in art direction ... architectural or realistic approach and the dramatic or creative' (1951: 76) often merge and overlap to varying degrees, creating a more flexible approach to place.

Conclusion

Wherever we are, the designer has been there first and ensured that the look and atmosphere of the place contributes to the story and character. What the place looks like or makes us feel is very much to do with the work of the designer. The actors move through architectural settings that are spatially designed for the medium and the designer brings the character to life through details like the colours of the walls, the clothes in the closet, what objects are on the bedside table, and so on, but also through the composition of these in the frame. In short, as Eunice Field has stated, 'it is his vision that brings to life Rick's *Casablanca* (1942), the lonely mansion on the prairie in *Giant* (1956), the oil trawler in *Alien* (1979), the cross country episodes of Art Carney and his cat in *Harry and Tonto* (1974)' (1980: 33). The next chapter investigates the process that delivers these places to the screen.

3 FROM CONCEPT TO CONSTRUCT

Immediately you have some images. You move on from there so dramatically because you start to research, you start to look at things, you start to visit real places so you do have to educate yourself very rapidly at the beginning and go at it with an open mind. (Stuart Craig, author interview, Windsor, 2000)

Making film and television is a process that starts with the idea for the script and culminates in the exhibition of the product. Within this structure is that of the production design. How do the initial concepts and sketches evolve and translate into the finished design? Clearly there is a distance travelled between first impressions, concept and the images we see on the screen. This chapter looks at the process of development, starting with instinctive responses and leading to the construction and dressing of the final set. The production designer scrutinises the script, developing a look and style for the production in terms of place and evocation of atmosphere through the setting. The creativity involved has specific boundaries, such as the budget and time-scale. The designer interprets the director's vision through sketches and models, which are eventually realised, constructed, decorated and dressed. In the words of John Terrence Marner, the designer 'has to tame his imagination into the hard and fascinating task of making all things physically possible for filming' (1974: 9).

The designer has a range of tools at their disposal. These include the practical and the conceptual: drawing board, paper, pencils, T-square, triangles, CAD*, architectural space, line, colour, pattern, repetition and contrast, observation, imagination, and research. These are all put

towards the central task of designing space. As J. Isaacs notes, 'designed space is the basic condition of cinema, inducing an empathic solidity from the two-dimensional surface' (1950: 81).

Through an analysis of some specific approaches, it is possible to identify particular designers' styles and imprint on the films they have worked on and to see how their vision has impacted on the final reading of the text. This suggests notions of the designer as auteur, the implication being that they have influenced how the finished product looks and feels to such an extent that it is recognisable. The exhibition 'Designed for Film: the Hollywood Art Director' (1978, Museum of Modern Art, New York) raised these issues and identified the 'signature' of the art director within the corporate vision of the studio system.

Charles Affron and Mirella Jona (1995) suggest that binomials like those used in music would be appropriate for the director/production designer partnership – a fascinating idea which is, however, problematic regarding the role of the cinematographer in the equation. The director, designer and cinematographer together bring about the look of the screen image, although the cinematographer is often brought in later than the designer, partially because they are more expensive. The collaboration between the many elements involved in film and television combine to create a fresh vision, and the inclusion of different ingredients is crucial for the end product to be successful. To see the production designer's first impressions, which can be a collection of simple line drawings, and how these evolve into the finished design and screen image, is to witness a bud come to bloom.

The process is influenced enormously by the director and their relationship with the designer. The earlier discussion starts, the clearer and more productive this alliance is. However, on some occasions no matter how early the dialogue begins the director and designer fail to establish a strong working association, which can have major implications for the end product.[1] The visual coherence may be lost over a lack of communication or there may be clashing, contradictory imagery due to too many different inputs. This is one of the reasons that directors and designers repeatedly work together, forming a creative collaboration that spans their careers, thus indicating its fundamental importance to the activity.[2]

Christopher Hobbs and Derek Jarman had a long and fruitful working relationship: 'It was just totally natural because the first films he did were not like structured films at all really; none of us actually knew how a film

was made' (Hobbs, author interview, London, 2000). Their collaboration grew out of learning about the process together: 'It was a hothouse. Derek had that effect; people swirled around him doing exciting things. When he found that people could do things he put them in the movie; there was a girl who was a tightrope walker so she walks across the washing line in *Jubilee*' (Ibid.)

Similarly, the production designer will often opt for the same art department, as trust and mutual respect has already been established. After working on *Shallow Grave* (1994) the same team reformed to make *Trainspotting* (1996): 'It was really good fun and all of us had a difficult time on *Shallow Grave* but we were all still friends, so when we did *Trainspotting* things were a lot easier' (Kave Quinn, author interview, London, 2000). Outlining the process here, albeit very briefly, will take in the different stages and give some examples to help clarify what these involve: script, shooting script, budget, schedule, sketch, research, concept, technical drawings, models, storyboard, location/studio, construction, decorating, dressing and props. These are all part of the operation and as such often overlap and feed into and off each other.

The script

A visual and emotional response to the script is a necessary starting point for the designer. The script will vary depending on genre, format, and so on, but one page per screen minute is a general rule of thumb for time considerations. On receiving the script, the designer will then break it down into locations, interiors and exteriors, day and night, period, and so on. From so doing they can begin to see the design possibilities, such as how many different settings there are, which could be anything from one (such as in *Rope* (1948)) to hundreds. For each setting a breakdown is produced for essential items that are actually listed, which might typically include everyday items like a telephone, clock and sofa. After this the designer can start to get under the skin of the characters and list everything else that may be in each and every location, from paintings on the wall and books on the shelf to more obscure items left lying around that can embellish our understanding of character and story. It is also at this stage that elements such as special effects will be noted.

This activity effectively involves rewriting the script in visuals. Wynn Thomas (who designed *Beautiful Mind* and *Malcolm X*), explains: 'When

I'm reading the script, I'm not just focusing on the words but also on the feelings they provoke in me ... my design process always starts with a conscious effort to articulate my emotional response to the script' (in Ettedgui 1999: 143).

The shooting script

The set is conceived in relation to the shooting script, which details the movements of the actors and the camera. It is crucial in allowing the designer to envisage the action and how the set will cater to this. The data also helps the designer to create a workable set that will actually be used, as without the shooting information whole areas of the set may be created that will never be in shot. Thus the shooting script is a time- and labour-saving device, a hugely practical tool that enables the designer to utilise their resources as fruitfully as possible.

The budget

The amount of money allocated for the art department is calculated in relation to the total budget and will typically be 10 per cent of that sum, thus providing a sliding scale whereby the designer will always have an amount that correlates with the overall budget of the production. What eventually appears on the screen is influenced enormously by how much money is available, but not necessarily in predictable ways. Some of Hitchcock's most stylish films, for instance, were created on tiny budgets: 'A vital part of the job on any film is to look at how much money you have to spend and be able to relate it to what you want to put on the screen' (Christopher Hobbs, author interview, London, 2000).

Production design, then, is about how the available money is spent as much as any of the other components at play. Film noirs of the 1940s are classic examples of budgetary influence on setting. The lack of money for extensive sets induced the need for sections to be lost in shadow, with key elements standing in and signifying the location, from seedy nightclub to sinister office. An aesthetic of enclosure and claustrophobia was thus born out of the restrictions of budget.

The script of *Prospero's Books* (1991) indicated 75 sets, which was unfeasible on the available budget. The designer's solution was to use one space and rework it. The same technique was used earlier in *Edward II*

(1991) and then *Gormenghast* (2000), where a series of blocks, on wheels of different sizes, are reconfigured for each new setting requirement. Such abstraction is not always appropriate and often there is no way around building a realistic interior setting. Laurence Williams, discussing television drama, soaps and sitcoms, explains:

> You know how much a set is going to cost, you're talking about a living-room set costing between four and seven thousand, a composite set of a kitchen, hallway and stairs costing twelve thousand. When you read the script you automatically put against it the costs then the props, maybe £600, and you just add them up. It's not very difficult. Of course, you know that whatever you put down it's going to be even more because there will be all sorts of things requested that aren't in the script. For inexperienced designers it can be a nightmare. (author interview, Elstree, 2000)

Thus we can see that designers unfamiliar with the costing of different productions might find this process very difficult. Caught between the requirements of the script and restricted resources there are limited options available; borrowing from friends and family, from shops with the incentive of a credit in the finished production, charity shops and auctions; or buying from antique and second-hand shops on the agreement that they will buy them back when shooting is over. Scouring the available means like this can be fruitful but also incredibly time-consuming. However, some items will always have to be bought, such as paint and consumable materials.

Shallow Grave was made on a small sum even by British low-budget standards (£150,000), but when asked what more money would have effected, Kave Quinn is keen to point out that it would have made the production less stressful. As an indication of how tight the budget was, she finished dressing the set with her own funds. This practice is possible when working on a contemporary production but becomes more difficult on period work. In contrast, Stuart Craig has worked on big-budget productions but found other constraints. Although he has designed on projects with budgets of £64 million, he has come out with less than the usual 10 per cent for the art department to work with.

The gulf that exists between film budgets is not necessarily translated into an equal distance in standard of entertainment or impact, but can indicate genre. For example, the same script produced on $20 million or

$600,000 will be approached in different ways – big budgets imply big stars and special effects.

Budgets and schedules are usually allocated early on, so that the designer can contain their ideas within these boundaries. However, sometimes the art department figure is decreased once the pre-production is underway. This arguably has a knock-on effect on the finished product: 'If you're going to cut the budget by a quarter you have to cut your expectations by a quarter' (Laurence Williams, author interview, Elstree, 2000). In such an instance the designer is put in a difficult position and can be shown in a negative light, because they have to tell the director that they cannot give them what they want for the money that is available: 'Art directors are never patted on the back for staying on budget. We are only rewarded for staying on budget and delivering a production that looks as though money was of no consideration whatsoever. Create wildly – spend wisely' (Christopher 1989: 32).

The shooting schedule

This is based on an equation of actor availability, set access and location groupings. The idea is to be as economical with time as possible, i.e. shooting everything that occurs in one location then moving on to the next makes more sense than returning to the same place throughout the course of the shoot. The schedule tries to take into account the length of time it will take to get a set ready and how long it will be needed before being struck and redressed while another one is used. Thus film and television are rarely shot in the chronological sequence of the script, but rather are broken into a more practical order for shooting requirements (a recent exception to this is *A Beautiful Mind* (2001), which was shot in story order to enhance the development of the main character).

Within schedules there are huge variations, such as a year to shoot a feature film, a few months on a television drama, and several days for a commercial. Keeping up with the shooting schedule is a genuine design factor; if the designs cannot be realistically achieved according to this then they are unworkable. Therefore the designer must have a strong sense of how long it will take to achieve the different looks and ideas and translate these in a realistic way.

One approach to this problem is to use the same space but continually 'revamp' it to appear as somewhere entirely different. Hammer House of

Horror used this technique at Bray studios in the 1950s and 1960s; the art department were working with a limited budget and revamping was one way to meet the deadline and story demands. On *My Beautiful Laundrette* (1985) the shooting was in reverse – the shiny new launderette was shot before the grotty old one. Hugo Luczyc-Wyhowski explains: 'Working with such a low budget, the scheduling was extremely important for the art department. The most expensive stuff has to be shot first so that it is in the can before the money runs out' (in Bancroft 1986: 18).

The research

At this point the designer casts out a net, examining closely what they catch for a clue to work as an organising principle. If the screenplay is adapted from a novel then going back to the original source material can be useful. If the script is based in another period, artefacts – such as books, drawings or photographs – from that time can help. Often, it is not specific design-led research but more general life observation that can provide the key.

In relation to locations beyond the realm of the designer's immediate experience,

a study trip is highly desirable for the designer, who must otherwise content himself with photographic references, drawings, paintings and the like. In either case the designer must distrust his first impulse, which pushes him to choose the most picturesque or exotic elements, instead of searching out the [location's] truly dominant characteristic. (Barsacq 1976: 127)

However, representation is an area loaded with meaning and can result in the creation or perpetuation of stereotypes. For example, the traditional iconography used to convey a city (red buses and landmark buildings in the case of London, for example) gives only one aspect of the place. Diversification from the norm can be an important consideration. For example, *It Always Rains on Sundays* (1947) explored areas of the East End of London and captured another aspect of the city.

For *EastEnders*, Laurence Williams conducted research into Italian restaurants in East London before designing 'Guiseppe's' for the television show. Having studied and found the 'real' designs impractical

he adapted his findings to produce his own version. Was the investigation in this instance worthwhile? The designs were produced from a position of knowledge – the research was adapted to suit the parameters of the production.

The concept

Coming up with the concept for the design is crucially important in getting the ensuing images to tie together and make a visual sense that supports and enhances the script through additions that create a new layer of meaning. Designer Richard MacDonald explains:

> Intuition is the only way for a production designer to discover what a director wants. If you ask him outright, very often he'll describe the opposite of what he really wants ... Eventually you narrow it down and you decide on a look. Without that concept, it's anyone's game ... You work to prevent that, to keep all the visual elements together so they add up to a whole. (in Mills 1982: 46)

Without the concept there is no overall design, just disparate sections of setting. Therefore one task of the designer is to conjure up the idea that will gel all of these into a composite whole. Stuart Craig tries to base his designs on just one or two ideas – any more than that and he feels it will not be as effective. The concept might take the form of a fundamental contrast at the crux of the story, such as was realised in *The English Patient* through pre-war opulence and post-war austerity.

References – for example painters, photographers, or other film and television – often provide a starting point. For instance, a key reference of *A Life Less Ordinary* was *A Matter of Life and Death* (1946), in terms of visual motifs and colour. The designer of *My Beautiful Laundrette*, Luczyc-Wyhowski, used the photographs of Robert Mapplethorpe and Helmut Newton as his sources. He also used Islamic art and architecture, National Front graffiti and the Pakistani national symbol of a horse. These elements worked conceptually to support his design with key ideas around sexuality and race. The underpinning notion for *Do the Right Thing* (1989) was to create a desert in the city, which was achieved through the use of colour and a lack of vegetation. A motif can engage the viewer, whether it is the garden of earthly delights (Beverly Hills in *Shampoo* (1975)) or the

decadence of the Roman Empire (Miami in *Scarface* (1983)). They operate on both a visual and metaphorical level.

The designer draws elements of enquiry together so that they make sense and work with the script to strengthen the end product. For example, Richard Sylbert says:

> I write a recipe for the design of each film I work on, e.g. *Chinatown* [1974], the colour palette must evoke heat and the absence of water. The spectrum in the film thus starts with the colour of burnt grass and goes through to amber, white, straw yellow to a brown shade of peanut butter. (in Ettedgui 1999: 40)

Similarly, Patricia Von Brandenstein creates a 'bible' containing components like the fabrics for the soft furnishing and costumes and the colours for walls and floors. Anna Asp characterises the houses she designs as different faces, such as God's face, a skull, and so on.

The concept can be hugely varied, plucked from a connection the designer has made with the script, and as such it is an exceptionally individual response. There is no right or wrong way of conceptualising, just some that seem to work more successfully than others, which tend to be those we remember – such as the greed that ran through films like *Fatal Attraction* (1987), *Wall Street* (1987) and *Indecent Proposal* (1993).

Dreams and memories

These are often used to evoke a time and mood to great effect. Dreams have certain similarities with film in that they are incredibly individual interpretations of the world. When Christopher Hobbs worked on Terrence Davies' *Long Day Closes* (1992), the impetus was to create Davies' home, not as it was but as he remembered it. One way of achieving this was in the scale, so that it did not tie in to the scale of the house as it had existed but as it had been recollected. 'Sets for a motion picture, whether dramatic or musical, relate to architecture: a dream-like architecture, entered and inhabited by the viewer through a subjective identification, which is unique to the medium' (Clarens & Corliss 1978: 28).

Leaving walls bare, without pictures or any other details, can promote a surreal quality where not all of the information is present – more impressionistic of a place. We can see the effect of this in Dante

Ferretti's work with Fellini (for example on *8½* (1963) where he gave us a sink without plumbing). Similar effects can be seen with Ferdinando Scarfiotti's work with Bertolucci (*Last Tango In Paris* (1972)), and Richard Sylbert's on *Carnal Knowledge* (1971): 'There's nothing there except for the light fixtures, until the last scene of the film where there is a photograph of her, the girl' (in Ettedgui 1999: 47). In this way, a reality is created that is more to do with the interior of the character than the external world they inhabit.

Colour palette

The psychological effects of colour can be harnessed in film design to suggest mood, plot developments and character. Key colours can be attributed to people or places. *Edward Scissorhands* (1990), for example, gave us a sugared-almond, pastel world of conformity and surface in contrast to the dramatic black environs that the key character had come from. Colour can thus be used as an organising principle behind the design. For example, in *Amadeus* (1984), a colour contrast was established that reflected the difference between Mozart's music and Salieri's. The modernism of Mozart equalled silver and pale pastels, while the more traditional music of Salieri was represented with darker pigments of red, gold and green. Again, the idea to create a desert in the city in *Do the Right Thing* was achieved through the use of colours that were very intense or earthbound. A particularly overt use of colour is seen in *The Cook, the Thief, His Wife and Her Lover* (1989), where red is used in the restaurant, green in the kitchen, white in the toilets, blue for the exteriors, and yellow for the Lover's antique book. Thus colour codes the whole film in terms of place and the costume colours tie in to provide a distinct awareness of how it may be used.

Colour options are usually discussed with the *director of photography (DP)** as soon as possible, as these are affected by the lighting design, film stock and processing. What appears as a golden yellow on the wall may appear fluorescent with the film stock the DP has chosen to shoot that scene with. Victor Kempster's colours on *U Turn* (1997) were in response to the choice of film stock (cross-processed 5239 reversal film, which is a hot chromatic stock that has a 'buzzed out, hallucinatory look' (Thompson 1997: 37)). Kempster used red and blue, which glowed against the arid landscape of the location (Superior, Arizona). Practical issues can

also affect these choices, for example the season in which the film is set changes the light and hue. And skin tones are predominantly red-based, so greens or greys provide the most complimentary background.

Designers' work can sometimes be recognised by their use of particular key colours – Patricia Von Brandenstein realised she was type-cast because of her love of pink and burgundy (see Clarens & Corliss 1986: 72).

Paintings

Paintings provide a useful inspiration and resource in terms of com-position, colour, light, mood, landscape and architecture and designers often draw on particular artists in this way. Kave Quinn created an effective and much emulated look when she chose to build for *Shallow Grave* a set with a palette based on Edward Hopper paintings. The film's distinctive colour scheme only deviated from this for the room that the Keith Allen character dies in, thus accentuating the different locations within one house while also suggesting that this room stands out in terms of plot. Interestingly, Hopper has been much used by designers and it is intriguing to see particular painters being used over and over again for different effect. Other references to Hopper include the Bates Motel in *Psycho* (1960), the Nighthawks bar in *Pennies From Heaven* (1981), and the American landscape in *Days of Heaven* (1978). Similarly the Norman Rockwell paintings used for *Blue Velvet* (1986) merged the familiar images of Americana with the screen design. Further,

> highly painterly is the only way to describe the look of *Blade Runner* [1982] which sets out to give its fantastic world an intricate texture of hi-gloss and technosleaze, of glitter and haze, rain and neon, crumbling stonework and torn body stockings. (Durgnat 1983: 43)

For an underpinning principle to be painterly does not necessarily imply reference to a particular painter, period or movement, but rather can be in terms of composition or light source, and also perhaps of expression over realism, to give a more stylised rendering of a scene: 'It's a Matisse aesthetic of visual pleasure, even if the story line is barbed with 1980s sleaze, cynicism and violence' (Durgnat 1983: 45 discussing *Diva* (1981)).

The relationship between the screen and painting took on another dimension in *Caravaggio* (1986), where the paintings are seen in varying

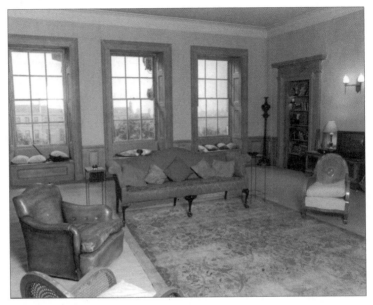

FIGURE 1 Sitting room in *Shallow Grave*

stages of completion and woven into the fabric of the story so that they seem to comment on the themes and characters. The viewer is presented with a scene being painted on canvas and given a special relationship to it. The figures being portrayed break their pose, talking amongst themselves. Christopher Hobbs produced these canvases at varying stages of completion to assist the narrative flow.[3]

Characters

Simply thinking about what possessions different characters surround themselves with, either intentionally or otherwise, can add depth to the story while providing visual interest to the screen. Whether it is a kitchen full of empty takeaway boxes (*Withnail & I* (1987)) or a houseplant that is transported to each new hotel room (*Léon* (1994)), the simplest and most everyday items provide a key to character. Henry Bumstead elaborates:

> Take Scottie Ferguson in *Vertigo* (1958). An ex-cop, probably not a great reader. I made him a philatelist and dressed a corner of his

living room with stamp magazines, magnifying glass and all the equipment a stamp collector uses. (in Ettedgui 1999:20)

Equally, where a person lives, works, or what colour predominates in those spaces can provide resonance. In *American Gigolo* (1980), for example, Julian's (the main character) apartment reflected an absence in his life. An elegant apartment in pale greys and blues, which was stylish yet empty and soulless. The nihilism of the character is also reflected in the key use of gym equipment and his wardrobe, these being the only elements that identify the space as his and which are chosen to indicate the emptiness of appearance.

In Jekyll's bedroom in *Mary Reilly* (Stephen Frears, 1996), the absence of clues is a comment on character too (figure 2). The essence of the story is the split personality, the fragmented nature of the key protagonist, who becomes two different people. The situation renders the technique of revealing nature through setting as problematic: which side of them is it that we are being given clues to? Thus, in the sketch there is little evidence of personality, a bland space that tells little – a mirror without reflection.

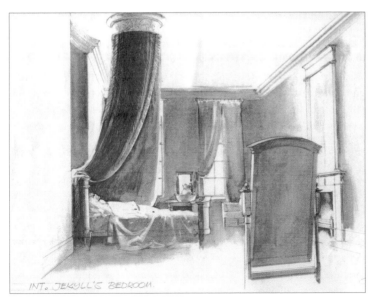

FIGURE 2 Jekyll's bedroom in *Mary Reilly*

Polarisation

Conveying the key contrast in the drama visually can promote ideas in the script. *About a Boy* (2002) identifies disparity in the homes of two of the main characters, one being clean and clinical (Hugh Grant), the other crowded and cosy with clutter (Toni Collette). The difference gives off a sense of character lifestyle and values that are in opposition to each other.

The superficial plastic environment of the dance studios in *Strictly Ballroom* (1992) is in conflict with the vibrant feast of life that is Fran's home. Her father's house, where friends hang out, eating and dancing with passion, is a shock to Scott, who has been brought up by his mother in a world of surface ('I'm wearing my happy face'), where winning the Pan-Pacific Grand Prix (ballroom dancing competition) is the key to happiness. The distinction is conveyed through colour, shape, texture and volume, that helps to tell story and character effortlessly.

The sequence/chronology

To get a sense of the order and progression some designers stick up photos of the locations in script sequence, thus making it apparent how these relate to each other, rather than seeing them all as separate entities. A systematic approach like this can provide a structure onto which more poetic, lyrical notions can be pinned.

A key image, colour, or architectural detail may be repeated to create and reiterate a sense of place, atmosphere, character or story. The repetition of water, the colour red, and glass in *Don't Look Now* (1973), for example, all work towards the ominous and inevitable conclusion.

Composition

Composition is fundamental in creating a sense of balance, and as such can be manipulated. From an architectural point of view volume can create a sense of depth. Some designers use grids to divide space into lines, which can then create symmetrical or deliberately asymmetrical shapes on the screen. For example, Ben Van Os used grids when working with Peter Greenaway, thus creating a depth and precision to the frame.

The composition can include gaps or shadows, and by suggesting certain shapes a place and time can be indicated, without necessarily

filling in all of the detail. Shapes may be created within the frame through composition, for example a triangle or circle, and these can be read as dynamic factors. Spaces are as important in this as objects.

The triangular composition in the opening sequence of *Once Upon a Time in the West* (1968) is created through the horizon and the train track; the angle is such that movement, energy, change and even violence, are foretold through this simple device.

Light source

The director of photography usually requires motivated light sources in a location to enable lighting design that makes sense; therefore where these practical lights are positioned has a fundamental influence on how a film is lit. For example, in *Edward II* this notion is subverted in that there are no windows, doors or practical lamps for the light to realistically come from. Instead the lighting is motivated by the emotion of the scene, which is hugely refreshing to see.

Indeed the issue of light takes precedence over furnishing for the designer. Two key choices that will influence the mood and look are whether to use windows and suggest natural light, or to use artificial lights in the form of lamps, candles, flickering television screen, and so forth. Minimal light sources provide the opportunity to create shape and volume through the manipulation of light and shadow.

The reality factor means that these concepts necessarily go through a practical process whereby time, money, resources and technical feasibility are equated. Lots of fabulous ideas literally do not make it past the drawing board because they are not possible in one way or another. The original idea must always be adapted to the realities of the production.

Pre-production

The period of preparation time can vary from a few weeks to several years – the average on a feature film or television drama is around two to three months. Within this duration the designer is required to conceptualise and research, draw, plan and build.

Mallet Stevens, who studied camera angles which varied according to the focus of the lens, made a key development in the way a designer was to work. Jean Perrier followed on from these, developing a set of ratios

that, with the relevant information on camera position and lens, produced the dimensions of the set that would be in the shot, thus determining how much of the set to design and build, saving time and money.[4]

Today this is a basic tool in pre-production, enabling the calculation of how much of the set will be seen, if the director and cinematographer go on to use the lenses discussed during pre-production. However, directors often stray from their original intentions, leaving designers with a dilemma. Thus many designers build four walls anyway, regardless of whether only two or three seem necessary at the outset, in order to provide a contingency plan.

Also essential in the pre-production phase is the hiring of crew. Often people are chosen on a word of mouth basis but there are art department agencies and diary services that have everyone from art department runner to scenic painter and production designer on their books.

The sketch

The sketch is an important development point for the designer, who will visualise initial responses to the script. This will include varying degrees of detail ranging from a few simple lines to exactly where the light is coming from and the precise location of props. Ken Adam considers, 'The sketch

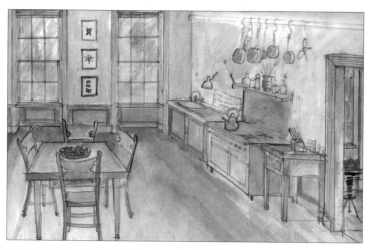

FIGURE 3 Kitchen sketch for *Shallow Grave* (Kave Quinn)

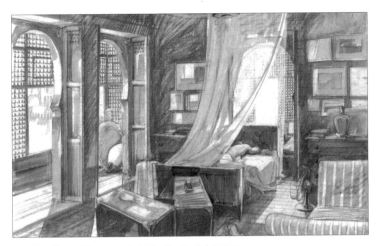

FIGURE 4 Almasy's bedroom sketch for *The English Patient*

is a designer's most important tool and must make clear which light is needed, direct or diffuse' (in Sylvester 2000: 51).

The spacious kitchen in the sketch for *Shallow Grave* (figure 3) is attractive – two large windows with the suggestion of greenery and foliage outside help promote a light and airy feel to the place. However, there is a sterile quality to the picture, with very little in the way of clutter or softness, and fabrics comprising wood, metal and enamel. This sense is heightened by the few details that are included, such as the three prints on the wall of dead insects. There is a plant but it is without leaves or flowers. Of the few kitchen utensils that are seen there is a large selection of knives, which rest on a butcher's block (a hint of what is to come) – even the humorous sign above the sink refers to death.

A very detailed sketch of Ralph Fiennes' room for *The English Patient* (figure 4) conveys an air of privilege and opulence immediately, but what elements connote that sense? It is light and airy, filled with the objects of a gentleman. The bed dominates and gives a sense of character, tied to the arrogance of wealth. The mosquito net that surrounds the bed is of practical necessity but also suggests that he is protected from life in other ways; nothing can penetrate or harm his refined, privileged existence.

Thus we see that the sketch is a powerful tool for suggesting atmosphere and character. A similar graphic aid to the pre-production process is the storyboard, which we will now examine.

The storyboard

The drawing of the script, shot by shot, in chronological sequence, shows on paper what will eventually appear on the screen. As such, details like the shot size, action, lighting and setting are all necessary in producing a storyboard. Once shooting commences this can be deviated from but is very helpful to fall back on.[5]

The storyboard from *Trainspotting* (figure 5) shows the toilet scene from the film, as it was intended during pre-production, where Renton is desperate for the toilet and finds the most disgusting one imaginable. He proceeds to relieve himself, only to realise that the drugs he had stored as suppositories are down the toilet too. He begins to peer down the bowl, taking in the foulness of it all, before plunging in head first, until his feet disappear. He enters a surreal underwater world, fish swim by, he locates the lost suppositories and swims back up into the light. His head appears out of the toilet bowl and he climbs out victorious. This scene is very close to that of the same scene in the finished film, which illustrates how the storyboard provides a template when it actually comes to shooting. An interesting deviation is the Dream Toilet, which was an idea to the other extreme, and was not used in the end but is helpful as an example of different ideas that exist in the early stages of a production (figure 6).

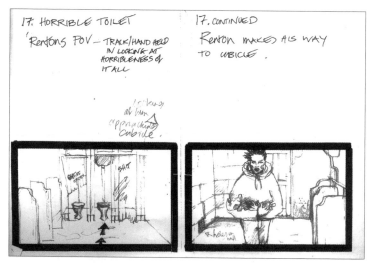

FIGURE 5 Storyboard for the toilet scene in *Trainspotting* – following pages (Kave Quinn)

17. 'RENTONS REACTION
HORROR REVULSION.

17. RENTON PUSHS DOOR
OPEN
'WINCES WITH DIGUST...'

18. RENTON LOCKS DOOR.

*(NOT SHOWN)
PULLS CHAIN
COMES OFF
(NOT SHOWN)*
DROPPING
TROUSERS)

18. DROPPING TROUSERS
MOVEMENT DOWN x
PULL OUT.

18. BIG CLOSE UP
RENTON CLOSES HIS EYES.
*(NOT SHOWN
Sc19 · MONTAGE/LIBRARY SHOTS
B52's SHED LOAD ON VIETNAM etc)*

20. BIGGER CLOSE UP
ON EYES (RENTONS)
SHUT
THEY SNAP OPEN ...

20. (CONTINUED)
HE LOOKS DOWN
BETWEEN HIS LEGS...

(CONTINUED)
20. HE DROPS HIS KNEES
IN FRONT OF BOWL...

20. (CONTINUED

... his legs, all disappearing...

NEW LARGER SIZE

21. RENTONS SWIMS
THROUGH MURKY DEPTHS
UNTIL he reaches the bottom

21. CONTINUED.

...He reaches the bottom, and picks up the suppositories

21. CONTINUED.

... He swims back towards surface with suppositories

22. INT HORRIBLE TOILET [TOILET IS EMPTY]
Suddenly Renton appears
through the bowl...

22. INT HORRIBLE TOILET
..LIFTS HIMSELF OUT ~ STILL
CLASPING HIS TWO SUPPOSITORIES
HE WALKS OUT OF TOILET.

LARGE KTOILE. (from bottom left).

22. CONTINUED
...HE WALKS OUT OF TOILET ...

16 DREAM TOILET
'Renton pushes door open
(he has dropped to ground)
pushes door open to see
a vision of TOILETDOM PERFECTION
(LIKE AN OASIS)

INCASED
IN GLASS
with GOLD
JOINS

Toilet on raised steps
white marble / toilet itself GOLD ↓

FIGURE 6 Dream toilet sequence

The two different storyboards for *Caravaggio* that follow indicate the film as it was eventually made and an entirely different approach. The first set illustrate a different use of storyboards in that they were intended to raise money for the project and actually propel it into production. The original storyboards for *Caravaggio* (figure 7) were very elaborate and based on the premise of filming in all the great palaces of Italy. The budget intervened, with only a small amount of funding from the BFI to produce the film on, their original grand plan would not be possible. Hence the notion was adapted to the use of key visual motifs that stood for Italy and these punctuate the frame rather than fill it (figure 8).

> Every now and then a bit of money would come in from somewhere and I'd go off to Rome and have a look at the paintings. Or we'd go off to Tuscany and sit in a little hill house that belonged to a friend (of the art dealers) and do storyboards, not for the special effects but so that they could be used to raise money. (Hobbs, author interview, London, 2000)

Thus we see that the idea changed quite dramatically from the initial concept to the finished film.

Location scouting

Different countries and regions have Film Commissions that list locations in their area and deal with production companies' needs in this respect. 'The Liverpool Film commission advertises itself internationally as a lookalike for ... Nazi Germany and cities of the Eastern bloc' (Miller 2000: 42). Reconnaissance is carried out to all possible locations to assess their suitability on practical, technical and aesthetic grounds. Is the location appropriate in terms of size (is it large enough to fit cast and crew), situation (too noisy next to a busy road, too difficult to get to in the middle of nowhere), decoration (is its character an element to be enhanced or disguised)?

Choices are made regarding what to build and what to use on location in existing interiors and exteriors. The decisions are reached based on practical and aesthetic factors. *Shallow Grave* (figure 9) was built predominantly on soundstages but that was not the designer's first impulse – having explored other possibilities it became the most plausible

FIGURE 7 Storyboard for *Caravaggio* as initially envisaged (and opposite)

SEQ 10(a) DEL MONTE'S LABORATORY

10 (b) DEL MONTE HANDS BACK CARAVAGGIO'S DAGGER.

FIGURE 8 Storyboards for the eventual budget version of *Caravaggio* (and opposite)

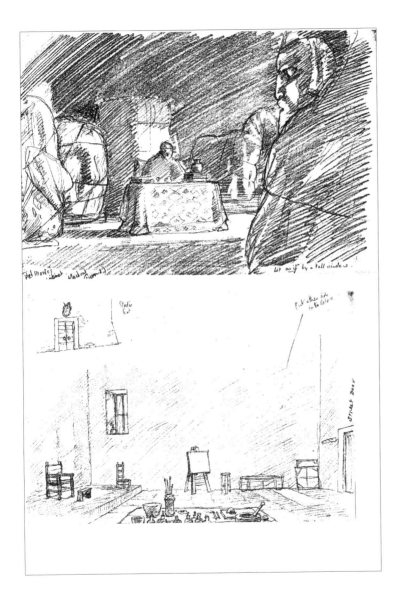

option. The main set was a big build – about 85 per cent of the film takes place in the flat. The layout of the flat meant that they had to build because after looking at lots of locations none of them were suitable: 'We looked at tons of locations and it actually wouldn't have been any cheaper to shoot it on location because there wasn't anywhere in Glasgow, so it would have been time wasted driving to and from the locations' (Kave Quinn, author interview, London, 2000). This illustrates the importance of finding the right location and also reiterates points made earlier in terms of time (schedule) and money (budget) implications. In contrast, for *Trainspotting* (figure 10) several real locations were used in conjunction with some building. These were repainted to tie in with the colours used in the rest of the film.

Technical drawings

Architectural drawings are made for all settings that are to be built. These are to scale and include dimensions, doors, windows and all architectural details. Who drafts these depends on the scale of the budget – it could be the designer, the art director or a separate draftsperson. These drawings are then given to the construction manager to start building.

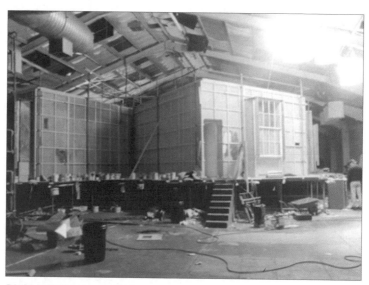

FIGURE 9 *Shallow Grave* soundstage

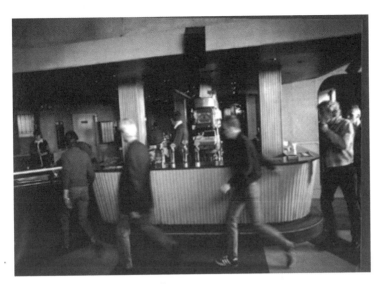

FIGURE 10 Edinburgh bar in *Trainspotting*

Models

A model of the set is sometimes constructed to scale, which can prove a useful device in helping the director and other key crew in the visualisation of the set and how it will work as a three-dimensional space. Having said this, some designers do not use models because directors cannot necessarily visualise the finished set through a *miniature**. A recent development on the model is the recording of it with a mini camera. This is perhaps more helpful in positioning the director within the space, as it replicates the spatial aspects more effectively than a scale model, which still involves a leap in terms of shrinking down to the size of the prototype (often only two or three feet in length, recently satirised in *Zoolander* (2001)). The models discussed here are not to be confused with those used in special effects, which are produced with the intention of shooting.

Construction

The technical drawings are usually built on studio sound stages where several can be erected at once. The system means that one set can be used for shooting while others are simultaneously being prepared and

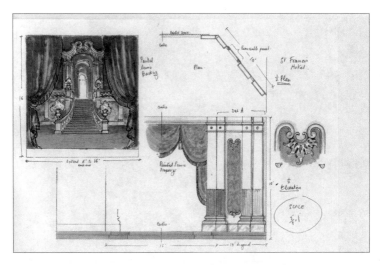

FIGURE 11 Elevation and detail for *Velvet Goldmine* (Christopher Hobbs)

dressed. For a television sitcom, there will be up to five sets in a studio, each shot with an audience. These sets are built with the audience in mind to ensure maximum visibility, which in turn influences the design style, often resulting in theatricality in that the set is opened out as on a stage.

Decorating

If using a studio, then once the set is built the next step is decorating, which may include painting, wallpapering, but also the art of rendering paint effects on different surfaces so as to resemble fabrics such as wood, marble, stone or brick. If shooting is taking place in a real interior, then decoration requirements will vary according to the existing space, often involving painting the location to fit with the colour scheme, and taking out furnishing and props that confuse or detract from the overall design concept.

Props

Prop buying and making will commence during pre-production. There are a number of prop houses that hire a vast array of objects to film and television. However, these are re-used by numerous productions,

which can result in certain props looking tired. Also, depending on how long the property is needed, this can prove expensive and eat into the art department budget. Prop makers produce original work, according to the specifications of the designer, and these, when effective, can really enrich the screen image: 'Every time Ken Russell wanted something nasty, a severed leg or a head or a corpse or something he'd ring me up and say "come and make something for me"' (Hobbs, author interview, London, 2000).

Props can also be borrowed, which is often the case on low-budget productions, where shops will receive a credit on the film in return for the use of items. These objects bring their own historical context, as Tashiro states,

> Objects exist independently of a story. In this state they have their own string of associations. Once placed in a narrative, objects and spaces acquire meaning specific to the film. While the overriding goal of the use of these objects is to serve story and character, these narrational elements frequently work at cross purposes. (1998: 9)

As already mentioned, props can be symbolic devices that reference themes that exist in the narrative. Patricia von Brandenstein said of *Amadeus*:

> I needed cities not studios. I needed London for wigs, Rome for costumes and fabric, Paris for ribbons. I needed acres of materials: hairspray, riplox, boxes of hairpins and hairnets, paper and ink to write the music on. In the Rome flea market I just got suitcases full of things to make eighteenth-century powder puffs, silver knife handles... (in Clarens & Corliss 1986: 4)

For *Caravaggio* there were very few props and each one had a specific function within the narrative – for example, the Eskimo knife that is at the centre of the story, a gold wreath, a sculpted foot, a head and a lion. The Byzantine lion and huge foot were casts from the British Museum. The head belonged to Derek Jarman, who had rescued it from The Slade Gallery. These were used to convey the idea that the Cardinal was a great art collector. The majority of the frame was shrouded in dust cloths. Due to

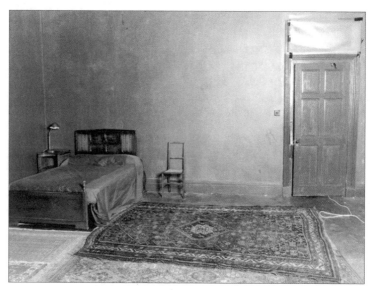

FIGURE 12 The spare room in *Shallow Grave*

restrictions of budget these details were meant to stand in for and indicate the wider collection: 'These objects are not the physical representations from a period but the social mores and structures of a given place and time' (Tashiro 1998: 67).

Also, the lack of props can present a strong image that generates mood or meaning in itself; for example the Keith Allen room in *Shallow Grave*. As this is the spare room, or the one that is to let in the shared house, it is reasonable that it has very little in it (figure 12). Therefore, the set operates on a practical level but also provides a haunting, empty image devoid of life. The wooden furniture stands out and looks all the more incongruous against the blue of the wall and the red of the bedspread. The wooden bed, chair and bedside table are softened only by a patchwork of rugs on the floor that give pattern and texture in relation to the smooth shiny surfaces of the remaining space – even the lamp is quite stark in appearance.

Set dressing

At this point in the process the set is furnished and propped by the set dresser, who will have plans from the designer to work to. The designer will

look at the set and rearrange and fine-tune the dressing. Clearly, what was planned on paper may need altering in reality. Also, at this time new ideas may be sparked by the environment, that can generate an energy about the set that wasn't present on paper. The kitchen sink overflowing with dirty dishes in *Withnail & I* was dressed using real food and takeaway remains that added to the squalid atmosphere. The kitchen sets in *The Godfather* (1972) were dressed to include the smell of garlic to enhance the centrality of food to the characters.

In *Trainspotting* (figure 13), the red carpet operates to control the space; most of the objects are positioned either on it or close by. The majority of the dressing is at floor level, which tells the audience something of the characters who inhabit this space, in that they appear to conduct their lives from a floor, horizontal level. The clutter comprises of cushions, empty cans of beer, old food containers and drugs paraphernalia. The slovenly scene offers a dynamic in the composition of the key props in a triangle. The difference between a discussion of the props and dressing hinges on the position and juxtaposition of these objects. It is their location in the frame and in relation to each other that creates a tension or mood. Set dressing is thus not only about the arrangement of everyday objects in a domestic space; it can be the degrading and dirtying down of a setting – in this case, water, dirt and graffiti all become part of the dressing.

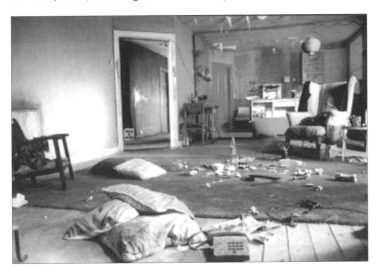

FIGURE 13 The squat in *Trainspotting*

Production

Once into production the designer's job continues. Depending on the size of the budget the designer may or may not be on set during shooting. Usually, on larger undertakings, there is an on-set art director, who ensures that their head of department's wishes are communicated. Meanwhile the designer will be setting up the next location ready for shooting. Some prefer not to see rushes because it may influence and dilute their ideas, whereas others consider it an essential part of the process, allowing an evaluation of which ideas are working and which are not.

Post-production

Special effects are undertaken during post-production, which further embellish the design of the images (see chapter 5).

During the editing process, certain footage will be discarded – it may be a wide shot or perhaps an entire setting. This can be a frustrating experience for the designer, who may have spent time, money and energy creating those images, but that is the reality of the job. Designers accept the situation as part of the activity; if not, contributing to the telling of the story footage ceases to be essential. This serves as a reminder that the work of the production designer is transient and unlikely to perform the functions it initially appears to.

Conclusion

The consummate design that appears on the screen has really been the product of an operation involving many skilled workers who have all influenced the final image, sometimes by constraint, often through embellishment. The complete construction may bear no resemblance whatsoever to the first impressions, as in the case of *Caravaggio*. Or it may be a three-dimensional representation of early sketches or storyboards, as in the toilet scene in *Trainspotting*. In short, as Shelly Ann Bancroft has written,

> The imaginative, practical and organisational versatility required from the film production designer today is reflected in the huge financial, creative and stylistic diversity of films made. And also by

the limitless wealth of imagery to work from, whether sources are art, architecture and sculpture; historic records; modern naturalistic urban, industrial or rural environments; or the boundless world of the imagination. (1986: 20)

The accomplished screen design is the product of a highly organised and rigorous practical business that is underpinned by a conceptual framework that has been created in response to themes and ideas embedded in the script. The practical process remains fundamentally the same, scaling up or down depending on the budget. While the concept is as hugely varied as the script, manifesting in motifs, colours, materials and space – sometimes subtly, at other times dramatically – it is guaranteed to influence the end product.

In the next chapter we will go on to look at the ways in which the production designer creates a sense of time or period.

4 TEXTURES IN TIME

'Rather than attempt the museum-like reproductions found in the British cinema, Hollywood designers usually tried to evoke the spirit of the period' (Mandelbaum 1985: 142). Thus the issues of authenticity and historical accuracy are pitted against those of the creation of a spirit or atmosphere redolent of the period. How this was and is achieved is the focus of this chapter. The use of different times as settings can do much to enrich the texture of the production. Leon Barsacq has commented:

> The spectator neither distracted nor disorientated by a hero in wig, tights, doublet, or toga, quickly forgets the minor differences in the outward appearance of the settings and costumes. This brings the characters and their emotions closer to him, to his sensibility with the added charm of a previous era. (1976: 128)

Screen images are set in time, the choice of which can change the interpretation of the narrative; in other words the same story can be told set in the past, present or future. When considering the representation of a time there are two distinctive areas to focus upon; first, the look of a period created during that being portrayed, and second, the evocation of another time (past or future). These two aspects influence the entire expression of screen images.

Film and television are fantastic documents of the time lived in as far as contemporary design is concerned – whether the work has a present-day setting, a period in the past, or one of the future, it gives away the era of its making. The question of the compartmentalisation of time is a debate that

spans many disciplines. When does one period close and another begin? Time is not linear and the manmade notion that it can be neatly packed into one box or another is contested. However, different points in time do have movements and trends that help to define them. Therefore, how one age is differentiated from another can be achieved through colour, shape, texture, or the materials used.

According to the *Oxford English Dictionary*, texture is the arrangement of threads in a fabric that gives it a characteristic feel, that which gives structure, to make by weaving to provide with texture. The texture then is referring to the way something looks and also how it feels. Thus, there are smooth, soft, shiny, sharp, rugged, hard, slippery surfaces of objects, structures and landscapes and the way these are combined results in a new texture. These have a surface appearance and a structure of feeling.

The invisible nature of some contemporary film and television will be examined with reference to the idea that seamless and apparently natural sets are the result of well-executed work. Soap operas and sitcoms seem to epitomise this idea because of their innately naturalistic codes. *EastEnders* will be considered to evaluate this point.

'Period drama' is a particularly popular genre with some highly recognisable features in terms of iconography. This makes it a fruitful area to study in order to see how the past is depicted on the screen. Is the role of design to attempt a historically accurate recreation of the period in question, or should it concentrate on conveying the essence or spirit of the time? Visual clichés which exist in this genre will be examined in an attempt to uncover why they have become so self-referential.

The role of props in this is crucial: what objects are chosen to define others and ourselves on both a superficial and psychological level? Film and television follow on from painting, literature and theatre in their need for a variety of props to assist in the development of the narrative. In every properties box in the Shakespearean theatre there was said to be a severed head, a crown, a sword and a white handkerchief. These indicate cultural and narrative trends of the time but would not be particularly helpful in conveying a contemporary script. Today guns, computers and mobile phones would be amongst the more relevant choices in a practical sense.

Props with a resonance on a metaphorical level may be less rooted in the everyday but tell the viewer about the spirit of the period, items that are not necessarily used in the action but make up the setting so as to locate

the story in time in an evocative way. It may be the font of a newspaper, the colour of paintwork, the pattern of wallpaper, the design of a cup and saucer. Each of these aspects contribute to the overall interpretation of a period, creating a significant feel of the time (influenced by traditions, trends and changing technologies). The depiction of the future involves a selection process of current artefacts and the projection of these, forward in time. Consider, for example, the umbrella taken to the future in *Blade Runner* (1982) and given a luminous tip, necessary for the extreme pollution that is forecast to exist then.

In order to gain a feel for these different times and their screen expression, it is useful to examine some examples of the representation of the past, present and future.

The past

Design is central to historical representation, whereby research is under-taken in an attempt to reconfigure another era and render it on the screen in a fashion that says, for example, and quite distinctly, seventeenth-century Rome, eighteenth-century Britain, or Biblical times. In this process, a shorthand is used, whereby key architectural shapes and details, or the props, colours and materials come to signify that time.

Films dealing with antiquity, whether Roman, Greek, Egyptian or biblical must be considered from a different viewpoint. These are merely pretexts for crowd scenes, for larger than life sets, for spectaculars reminiscent of *Cabiria* [1914] and the great age of Italian cinema. (Barsacq 1976: 135)

Historical drama is often the area of design that is most recognised, perhaps because it is more tangible than contemporary design. The world that is created is different from that currently inhabited and as such its construction cannot be invisible to the audience. The colour palette used is often striking due to the technology of dyes and pigments, as are the textures, shapes and dimensions. The technology of production influences the artefacts created. Should the object be recreated in the way it would have been originally? The reconstruction of a period can not be wholly accurate for a number of reasons: 'Architecture, fashions and life styles,

influenced by economic and social conditions, produced behaviour, speech patterns and even emotions that are so far removed from our own habits and mentality' (Barsacq 1976: 130).

According to C.S. Tashiro (1998), realist history rests on a superficial representation of the past, that is to say it strives to replicate the surface appearance of a period in an effort for historical accuracy. However, this portrayal can lack depth or meaning, relying on appearance alone, and creating a soulless vision of the past.

Britain's history is a major selling point in terms of commercial film-making and has been criticised for creating a romanticised nostalgic picture of a past that never really existed; the success of which has resulted in perpetuation with each new production seemingly building on the preconceptions and visual lacquer of the previous. In a recent article in *The Times* Roland White pointed out:

> The first episode of a new drama, especially a costume drama, normally takes its time. There are people in wigs to be introduced, scenes to be set, young lovers to be united, carriages to be driven across cobbles. But the *Forsyte Saga* didn't bother with all that ... One of the problems of costume dramas is that the costume is often more important than the drama. (2002: 12)

The proud display of period costume and setting became synonymous with a range of adaptations produced in the 1980s and early 1990s: *Brideshead Revisited* (1981), *A Room With a View* (1986), *Maurice* (1987), *Howards End* (1991), *The Remains of the Day* (1993), and so on. The mention of Merchant and Ivory implied key characteristics of English houses, gardens and landscapes, afternoon tea, picnics and boating. The setting is given prominence and there is pleasure in these details; the audience is wrapped in the comfort blanket of the past.

According to Tashiro, historical *mise-en-scène* concentrates on two extremes of space: exotic details that confirm the credentials of the period and large-scale exteriors. However, these devices can be overused to the detriment of authenticity. 'The images are charming and sanitised ... scrubbed version of historical films produced in Hollywood in the 1940s and 1950s, in which the Middle Ages are presented as bright, clean, noble, sporting and merry' (Driver 1999: 5).

Films such as *Sense and Sensibility* (1996), *Jude* (1996) and *Elizabeth* (1998) exemplify a departure, an attempt to produce a more lived-in, even sordid, brutal past:

Jude ... set out deliberately to challenge and disrupt the heritage tradition. It shies away from anything remotely picturesque or romantic. Some scenes are reminiscent of stage sets and the painterly tableaux are sometimes dependent on the poses and groupings to be found in Victorian narrative painting, for example, the scene where Merton kneels beside Milly to beg forgiveness as she lies, near death on a chaise longue. Here again costumes and décor complement each other, the curtains, the sofa and his suit are all cream, as are the walls behind them. (Church Gibson 2000: 121)

Thus, a grittier approach does not preclude the pleasure of the setting, but it may continue to lack a sense of personality. According to Tashiro,

[h]istorical décor functions as a general background of familiar cultural props that convey importance and lend impersonal significance. This impersonality proves the narratives social and historical validity, since the space is not controlled by the concerns of individuals but by larger social forces of history. The History film keeps décor and character figuratively and literally separate. No effort is made to make space reflect emotions. (Tashiro 1998: 69)

The BBC adaptation of *Vanity Fair* (1999) (designed by Malcolm Thornton) was refreshing in its representation of the eighteenth century. Contrasts were provided between the settings based on the personality of the occupier. For example, the environment of the main character, Becky Sharp, changes to reflect her social status and on her upward climb her home is highly ornamented, with flowers, candles and figurines, in red, pink, cream and gold. Furnishings are soft and cushioned, with diffuse light – even the wall hanging is of tapestry fabric rather than the stretched canvas and wood of a painting. Mirrors feature strongly and it is clear that the appearance of this character is highly appealing. Amelia's home, on the other hand, is quite austere, with a lot of dark wood, which contrasts starkly with the puritanical white of the walls. The characters' appearance belies their true natures – put simply, Becky is ruthless and cold while

Amelia is warm and kind. The surface texture of their habitat does not reflect this, which supports the narrative simply and effectively as one of superficial appearance and vanity over genuine integrity. Stairways present themselves at key points, for example when the Crawleys move to Mayfair, in an attempt to engage in high society, they are framed standing at the bottom of the staircase looking up. *Vanity Fair* exhibits beautiful and articulate design that is stylised in its use of texture, while remaining 'true' to many of the conventions of period drama.

Even if it were possible to define exactly how a particular place in time would have looked there would still be the issue of recreation. In order to recall the place it must be built, decorated and dressed. During this process choices will be made based on practical issues such as time and money, which will influence the eventual design. For example, to obtain the authentic furnishing fabric may prove too expensive so a cheaper alternative is produced. Props that were supposed to be custom-made could take too long, which means they must be picked off the shelf of the prop house. Thus, it is easy to see how practical and technical issues may impact on the ideal process.

An effective prop, for instance, can stand for the film as a whole by distilling the period, character and narrative. According to Stuart Craig, in every film there are one or two objects that become really special; 90 per cent of effort has gone into that one thing and it becomes a trophy at the end of the film.

I'm thinking of the book in *English Patient* [1996], so much love was poured into the making of that thing, Ralph Fiennes' drawings went into it, it was lovingly bound in leather by a book binder in Rome and aged with real sweat from real palms. In the *Elephant Man* [1980] he made a model of the church of Whitechapel road and it becomes a great symbol of the film. There isn't anything out there externally that I reach for as a kind of comfort blanket but there are things that we've made. (Craig, author interview, Windsor, 2000)

Items like these become icons of the film – it is through the book in *The English Patient* that his story unfolds. The notebook works as an action prop in that it is literally essential to the story but also its design speaks of character and story too. Its appearance and contents create a particular texture; the smooth aged leather, the soft cream pages and the inky

entries of elongated calligraphy are chosen to convey keys to the character of his life and times.

Prop houses contain a vast selection of articles, from small intricate ornaments through furniture and body parts to weapons of war. These resources, however, are used repeatedly by a number of productions for both film and television, so it is not at all unusual to see the same items appear time and time again. This is particularly true in period drama for which the stock of props is limited. So, although there is the problem of repetition to take into consideration, without prop houses the cost of constantly reproducing items for a single production would be enormous. 'There isn't much of that Jane Austen period in the prop houses', Hobbs has commented, 'so I've used the same harp as three other films and you get a bit pissed off about it' (author interview, London, 2000).

In order to overcome this issue, a designer may range a variety of sources during his/her research:

> By drawing his inspiration from eyewitness sources such as paintings, engravings, miniatures, tapestries or bas reliefs, the designer will find, in addition to purely material details, an indication of the general spirit in which the film should be treated. (Barsacq 1976: 130)

Adopting these less obvious modes of research it may be possible to come up with a look that retains a sense of the period without the viewer feeling that they have seen it many times before.

Yet according to Robert Mallet-Stevens the spectator should find on the screen the vision of the past to which he is accustomed (1927: 130). Why should this be the case? There are many different pasts, as seen today in the deliberate diversifying of history from myriad perspectives, giving voice to those whose stories may previously have been marginalised. Thus, the notion that the screen image should conform to other screen images that have gone before seems limiting and dull. Indeed, in attempting to represent a particular period of time there is scope to reinvigorate both how it looks and how it feels. Through this effective reinterpretation the audience may gain insight into the era as it was lived rather than simply the precise formation of its furniture.

> Every Production Designer working on a period film knows that whether striving for the invisibly realist background or

the assertive, spectacular foreground he or she must confront difference as the overriding quality of the historical image. Even film-makers self-consciously using an anti-illusionist approach to the past must face this expectation as a convention to be fought, subverted, ignored or evaded. (Tashiro 1998: 63)

One way of drawing attention to the construction of the past on the screen is to throw in deliberate elements that are out of context. In *Caravaggio* (1986), for example, set essentially in sixteenth-century Italy, there are intentional period anachronisms, such as magazines, typewriters, the sound of motorised vehicles. This is playful and consciously challenges the ideas around historical accuracy and genre convention. The film juxtaposes numerous period details and in so doing draws focus and demands the full attention of the audience. By denying the comfortable codes expected in this genre, *Caravaggio* engages the viewer through its depiction with a dynamic visual flare.[1]

In mainstream period work, it is precisely these elements that must be eradicated to promote the seamless nature of the product. For example, telegraph poles or electricity pylons are considered a menace on exteriors, and when a designer does accidentally allow something out of time into the shot this is termed a 'howler', i.e. undesirable and rather embarrassing.

Turning to the more recent past, there are generally a wealth of references; with increased options, designing can be more diverse. Memory of the period and films made during that time also come into the equation. *Absolute Beginners* (1986), for example, was made in the 1980s and was a studio-bound impression of 1950s London. *Carlito's Way* (1993) brought the 1970s back to us, with silhouette and mood in the 1990s. These are films that exhibit a strong and deliberate style, controlled and confident in the choice of elements chosen to encapsulate the era.

Dick Tracy (1990) captured the essence of 1930s and 1940s New York, conjuring an atmosphere that was redolent of the period if not historically accurate. One way in which this was achieved was through the manipulation of colour – in order to echo comic-strip colours only primary and a few secondary colours were used. The technique used to create *Dick Tracy* relied on the comic strip further in the use of *matte** shots that blended highly stylised backdrops with the foreground detail, the essential idea being that the artificiality was part of the design and was therefore to be made apparent.

Self-reflexive approaches are quite a reversal of much production design, which as already discussed attempts to hide the seams of its own creation. Such old-fashioned methods as these have been used since by film-makers like Quentin Tarantino, who employs back projections for car scenes, paying homage to the films of the studio era, a system in which this approach was first used. Such reflexivity is a knowing nod to the audience who understands the past as mediated through cinematic images.

A particularly effective depiction of the recent past can be found in Todd Haynes' *Velvet Goldmine* (designed by Christopher Hobbs). Made in 1998, the film invokes the 1970s through a strong sense of colour and shape. The silhouette underpins the transformation from past to present and helps to visually delineate the time. In the sections set during the 1970s, long flowing hair, dresses and cloaks swoosh and swirl around the frame; they occupy space. These contrast with the present, which is quite conservative and clipped; the shapes have shrunk and closed in on themselves. The texture of the past looks familiar and yet stylised; the swirling carpet design, the brown and orange furnishings, are all iconic of the 1970s but have been exaggerated to give a strong sense of nostalgia around that period. Sitting in the present in a plain room, the flashbacks sections operate as if a big box of fancy dress has been opened, filling the room with colour and exotic shapes, with rich textures of velvet, feather and leather.

> However, we know the past did not look the way the present does. We know this because other disciplines equally dependent on surface appearance – art history and archaeology lay substantial claim to our sense of historical truth. Our knowledge that our reality does not appear as it does on screen immediately marks the historical image as stylised, thus fictional. (Tashiro 1998: 64)

It is this rupturing of the otherwise invisible nature of much of the designers' work that can lead to an over-emphasis on period design. As Stuart Craig states,

> This kind of heritage England that we're all involved in promoting; it's true American producers come here for that and those films always win Academy Awards. And it's absurd, it's actually easier in many ways than a contemporary film, the options are fewer,

the selection has already been made by history and the prop houses. When you do contemporary film, the choices are infinite and therefore it's much harder to be discerning. (author interview, Windsor, 2000)

The present

In the 1920s Mallet-Stevens illustrated that the problem with being fashionable is that it is fleeting. He presented a collection of modern film design photos as if these would be definitive and retain their cutting edge. However, the more fashionable the designs are now, the more likely they are to look dated and old-fashioned in the future. What is it that ages them to such a degree? It may be the material used, for example a Formica table or a plastic chair. Alternatively, it could be an object's shape, that of an Alessi kettle (1985) or a Wassilly chair (1925). Striking new products shriek of innovation and the moment.

The length of time it takes to produce a film often means that something considered the height of fashion in pre-production is quite passé by the time of exhibition. However, certain trends exist within film-making that result in crops of similar films being released around the same time, a sort of cinematic zeitgeist – for example the range of disaster films around the turn of the millennium, exhibiting the latest in special effects.

In order to ascertain precisely what film and television texts have been responsible for defining the times, we will continue by considering some distinctive periods of contemporary design, from the Hollywood studios, German Expressionism, film noir and musicals to current TV shows like *Pop Idol, Who Wants To Be a Millionaire* and *The Weakest Link*.

In much the same way that the star system was used as a marketing tool, the look of the studio used to be a distinct selling point. Genre and look were tied in as points of recognition so that the audience knew Universal created horror and Warners gangster films. Thus the art departments were encouraged to make their output adhere to the distinctive styles of their home studio.

In 1932 an exhibition about modern architecture was mounted at the Museum of Modern Art, New York, entitled 'The International Style', and its ideas were quite swiftly incorporated into Hollywood sets. It had been usual for Hollywood to make the most of its amazing skyline and whenever the opportunity arose back projection and painted backdrops would

provide a view of the horizon.[2] The skyscraper was a symbol of modern American architecture and its imagery was repeated in the cinema. During the Depression, film skyscrapers were among the few buildings actually being constructed.

Between the wars there was an influx of European exiles into the US, who had great influence over Hollywood's design. Paramount had a particularly German influence in Hans Dreier, the supervising art director whose, art department was likened to a Bauhaus workshop. Comprised of an eclectic mix, including architects who due to the reduction of building construction began working in other areas such as that of film design. This inevitably influenced the design of the time and introduced the audience to a feast of modern architecture.

Paramount during the 1930s, then, was closely aligned to the Bauhaus, in its visual cues, such as clean white surfaces and elegant simplicity. In fact the white set became a hallmark of Paramount, a previously impossible task due to restrictions of technology. During the 1930s developments in film stock and lighting allowed designers to play with different shades of white, all within the same set, creating a stunning aesthetic which is unmistakable of the era.[3] The use of diffused lighting was groundbreaking at the time and created a glowing effect on the walls. Thus the Big White Set was definitive of the studio at that time and was a product of both aesthetic and technical innovation.[4]

> With their flat, undecorated planes and weightless volumes set into asymmetrical compositions, the modern sets created at Paramount studios during the 1930s shared architectural characteristics with many of the buildings of the European avant-garde. (Albrecht 1986: 84)

The fabrics used to create the sets were equally inimitable: 'Glass bricks, Bakelite and tubular furniture travelled from the European avant garde to the American heartland via the Hollywood studios' (Gavenas 1989: 24).

Van Nest Polglase was the supervising art director at RKO, which sported a far busier design look than Paramount. Their sets had a more decorative quality, combining art deco, neo-classicism and modern architecture. RKO is attributed with creating the black and white set which played on and exaggerated contrast; a striking and memorable visual but considered less successful in design terms because it allowed these

decorative motifs to dominate the more fundamental considerations of form and volume.

The MGM art department headed by Cedric Gibbons has been noted as producing the largest body of modernist sets, which are considered highly successful designs from concept to construct. As discussed in chapter 1, Gibbons was a well-known figure who had high status in Hollywood at the time. He certainly influenced the end product, battling to get what he wanted, whether it was over money, time, or the design itself. Therefore, what is eventually seen and now defines those films has been influenced by the structure of the studio and the personalities involved, exemplifying how persona impacts on the texture of the time as dramatically as the exigencies of fashion. After attending the 1925 Exposition des Arts Decoratifs et Industriels Modernes in Paris, Gibbons adopted art deco style for *Our Dancing Daughters* (1928). 'Gibbons' flurry of squared off columnar fireplace, the mirrors repeating the rooms into blackness and the asymmetrical border containing these mirrors, which spells out luxury and a sensual mystery with admirable economy' (Dowding 1982: 27).

MGM's success ultimately lay in its ability to combine the elegant architectural sensibility of Paramount with the energetic decorative qualities of RKO. The perfect balance achieved between the two has left us the most valuable design legacy of any Hollywood studio (see Albrecht 1986: 99).

The relationship between cinema and fashion can be interdependant; for example, in the late 1920s MGM launched a magazine, *Art Deco décor*, which it was hoped would encourage the audience to emulate the designs from the screen in their own homes. Some modest decorating ideas did catch on in the form of Venetian blinds, dancing figurines and indirect lighting. So too did the more extravagant designs: 'Screen stars turned their bathrooms into De Millian sets and housewives redecorated after reading about Charles Ray's $75,000 cut glass bathtub and Gloria Swanson's golden tub surrounded by black marble' (Mandelbaum 1985: 40).

By the time of the 1939 New York World's Fair modern décor had shrunk from view in film design.[6] This was for a number of reasons; World War Two was about to break out, there was a general move towards realism and the modern movement itself was dissolving. In Germany, the Nazi government was the antithesis of modernism's socialist and internationalist ideology. Design-based influences on Hollywood were also at play. In America

revived interest in Frank Lloyd Wright made a more traditional, natural look desirable.

With the decline of modernism came a more subdued look from MGM, which incorporated colonial revivalism, softening the strength of the deco. *Manproof* (1938) signals the change towards more traditional architecture and fabrics, returning to symmetry and solid walls, as opposed to open planning and the use of wood, stone, textured wallpaper and fitted carpets.[5] 'Upholstered chairs and sofas in traditional fabrics', Donald Albrecht has noted, 'took the place of tubular furniture' (1986: 107).

During the 1930s these trends could be seen as an indication of fear of the future and a wish to return to the comfort and security of the past. South American influences appeared in the form of wicker and straw furnishings and palm tree motifs. This was because the war had taken away the European market and a fresh audience was identified in South America.

By the mid-1960s the studios had lost their consistency of look, which actually assists in its identification as a distinct period today.

Looking more specifically at genre, the musical provides a vivid example of a texture in time in that it looks and feels like a specific period that was the product of a context that no longer exists. Musicals signify theatrical extravagance and fantasy over attempts to construct reality, and as such the design opportunities are liberated from the constraints that exist in many other screen genres.

Busby Berkeley's *42nd Street* (1933) was the forerunner for this genre, with its distinctive design that allowed for the action and camera in a highly choreographed sense. Key motifs included stairways that stretched to infinity, fountains, white pianos, gliding columns, mirrors, waterfalls and human harps.

Berkeley came from Broadway, where he had made his mark with synchronised dance formations. Once in Hollywood he added the movement of the camera to his intricate choreography to create a whole new look on the screen. He also used one camera as opposed to four, which until previously had been the norm in that genre. His designers included Richard Day and Anton Grot, who created sets that were almost organic in their multifaceted ability to adapt and transform for each new number. Thus the sets were designed to allow for ease of movement in order to open and close smoothly and quickly. The symmetrical and geometric patterns of dancers would kaleidoscope and multiply with

machine-like precision. Here is another example of a genre that really used the potential of design but not in conjunction with plot, leaving characters bereft of substance.

One would think that manifestly artificial fantastic sets, exempt from the burden of realism, would also be exempt from criticism about decorative excess. (Affron & Jona 1995: 182)

Vincente Minelli was responsible for breathing new life into the genre.[7] The look of his musicals became more important than the story and attempts toward realistic-looking settings were minimal. Highlighting its own artificiality, through a combination of lyrical and theatrical visuals, the design bore no relation to real places. It was particularly exciting that it was embraced then despite such non-conformity.

Joseph Urban designed musicals for Hearst over a ten-year period. With 25 films theirs was a body of work with a distinctly overt design aesthetic, which was often based in fantasy. However, these films were criticised in reviews of the time for their superficially beautiful sets without sufficient story or character substance

'The Astaire and Rogers series was the pinnacle of Art Deco design, a Manhattan of the mind where nights were danced away in an aura of luxury and elegance' (Mandelbaum 1985: 142). Streamlining created aerodynamic shapes that became a major motif, which complemented the dances and tied the overall design together, providing a balanced production.

These open plan streamlined sets also had their practical advantages. Unlike a traditional floor plan, Art Deco lent itself to open spaces far easier camera manoeuvrability, false perspectives for greater illusion of depth, high-intensity lighting for easier filming and large relatively blank backgrounds for easier framing of action (see Foley 1989).

Later musicals were influenced by the move into the streets and the use of real locations. *On The Town* (1949) featured the real streets of New York, followed by *West Side Story* in 1961, which fused the real streets of New York with stylised settings that used colour to help articulate character.

More recently, the distinctive construction of the musical was recognised in *Moulin Rouge* (2001), with deliberate reference to its visual cues in a celebration of its artifice.[8]

Places take on different connotations and meanings at different times. Thus, during the studio period, particular locations looked and acted in

a specified way. The kitchen would act as the home of domestic bliss, while hotels signalled the promise of adventure. Feminist issues are geographically situated in terms of the use of the home and the workplace. The kitchen, bedroom and bathroom became sites of conflict, where sexuality and domesticity would fight it out. According to Albrecht (1986), designers were also able to fall back on tried and true signifiers of sexual danger. For instance, lamp stands decorated with cobras, octopus-shaped clocks and mirrors framed with bat wings hint at lethal and entrapping sexuality, a reading which illustrates the temporal nature of certain design motifs.

Particular places also indicate specific periods of design. The majority of offices seen in film during the 1920s and 1930s, for instance, were those of glamorous businesses such as media and fashion. A sexy place of work equipped with beautifully streamlined and regimented desks, leading to an ornate and particularly sleek one, dressed with a few key slick and ultramodern props (rolodex, typewriter and telephone) is an icon of the time. This era has been referenced since in films like *The Hudsucker Proxy*, which exaggerates and plays with the office setting and status symbols of power.

Nightclubs were the ultimate in escapism, with design motifs heightened and exaggerated to present a glamorous environ of shimmering light. The greatest deco nightclubs did not appear until the early 1930s, when the end of prohibition was near (see Mandelbaum 1985: 102).

Cecil B. DeMille is credited with bringing bathrooms to prominence on the screen. The bathrooms of that period became luxurious and sensual, made from marble, onyx and chrome. The bathing scene from De Mille's *Male and Female* (1919), where Gloria Swanson climbed into a sunken bath, was trend-setting. Bubble bath conjures up ideas of film stars luxuriating in utter pleasure; an icon of ecstasy, born out of the need to prevent the audience from seeing naked flesh. In *The Crowd* (1928), a shot of a commode was found deeply shocking and taboo in the open display of bodily functions. Today we not only see toilets but we plunge down them (as in *Trainspotting*), nicely illustrating how time influences audience readings of imagery and place.

Considering more expansive spaces, hotels symbolise social mobility; hotel lobbies signal movement, as do stairways, lifts and revolving doors. Large hotels were replaced by motels during the postwar period. The change of place affected the tone; hotels being public meeting places,

motels being private and antisocial. The seclusion of the Bates Motel, for example, is totally entwined with the story – a hotel would not have supported the narrative in the same way.

Cruise ships – hotels on the water – were another luxurious social setting associated with the times. They operated as images of speed, technology and escape, through an articulate expression of streamlining. Genres implicit in this setting were romance, murder mystery plots and disaster. Ocean liners continue to evoke these ideas as if set in aspic.

As a movement, German expressionism has had a considerable effect on the present. *The Cabinet of Dr Caligari* (1919), for example, stands out provocatively today, with its extreme aesthetic and ideology. Perhaps because it is so clearly located in the time of its making, it has become a strong signifier. It is worth noting that this and other expressionist films were made entirely in the studio, thus reiterating notions from chapter 2 regarding the artificiality of construction as opposed to the reality of the street. A key point is the fact that after striving for the illusion of three-dimensionality in film, the two dimensions of the medium were made apparent. In so doing, other apparently natural and normal constructs were criticised, such as the politics and underpinning ideology of the country at the time.

Film noir attempted to get to grips with serious issues during the 1940s, which was reflected in their visual style. The genre is a fascinating product of its times, influenced by expressionism and seemingly kicking against modernism in its closed, shady environs that bear no relation to any of Le Corbusier's notions of modern living.[9] The *mise-en-scène* created in film noir of the 1940s resulted in a strong and recognisable style that has been picked up and adapted since.

Italian Neo-realist film-makers intended to use real places rather than studio artifice to tell their stories. *Bicycle Thieves* (1948) gives a down-to-earth view of Rome through the eyes of an unemployed man. This was followed by the French New Wave and British social realism: 'The new filmmakers in Britain and France make explicit their independence from the conventions of décor that had dominated their national cinemas' (Affron & Jona 1995: 2). The texture of these films could be contrasted sharply with the escapist settings of musicals. Indeed, Jean-Luc Godard parodied the conventions of the musical as part of his realist project. The result is a gritty, grimy, urban look that utilises real streets and locations aligned

with the social realism of the subject matter, which dealt with working-class people. In *Cathy Come Home* (1966), for example, the subject was homelessness, which was a genuine issue along with unemployment, domestic violence and unwanted pregnancy. Thus, 'British New Wave context summarised the disappearance of the British Empire, the growth of a distinctive youth culture, the rise of working class affluence and the revival of an intellectual Left' (Chibnall 1999: 82).

The Avengers television series in the 1960s developed an iconography, which sprung from its limited budget. Deserted airfields, buildings and streets created a sparse appearance that captured the architecture of the time with very few frills: an image of young swinging London, without litter or cluttered detail. Recently a film was made of the series, which faced the challenge of recreating this romantic London: 'The expensive sets, such as Emma's gorgeous sixties pad, complete with mock Warhol screenprint invoke the mid 60s TV Avengers on a vastly grander scale' (Day 2001: 232).

The television series created an original and identifiable style, which renders it feasible in terms of recycling, based on the notion of pleasure through intertextual recognition. However, the film was unsuccessful critically and commercially: 'The calculated sets and computer generated images empty out the more makeshift and "found" resonances of the original series, made at pace and ragged round the edges' (Ibid.).

The term 'postmodernism' is a site of struggle and there is no clear consensus on its meaning. According to Fredric Jameson, postmodernism is a schizophrenic culture, in a Lacanian sense, registering a failure of temporal signifiers. He exemplifies this theory through what he calls the nostalgia film, which he says sets out to recapture the atmosphere and stylistic nuances of the past. Films that could be included in this category are *Rumble Fish* (1983), *Blue Velvet* (1986), and *Angel Heart* (1987). This can also be applied to films set in the future, such as *Star Wars* (1977) and *Blade Runner*. They perpetuate a 'false realism', regurgitating myths and stereotypes from representations of representations.

This deliberate reworking of past texts was preceded by the reworking of past settings for practical purposes. Production designer Robert Chatsworthy explains how he approached the design for *Psycho*: '*Psycho* was a little quickie picture for Hitchcock, only four weeks to prepare and shoot. The Bates house – for the roof we borrowed parts from the rooftop of the house that was built for *Harvey* (ten years earlier)' (Stein 1975: 32).

Thus, the studio system itself could be identified as creating a cinematic sense of déjà vu through its practice of recycling setting and props. The loss of clear historical differentiation, juxtaposing different ingredients from different times, can also be used in the architecture itself. The butting together of old forms in new ways due to a lack of the new can produce potent results.

Discussing the making of Derek Jarman's *Jubilee,* Christopher Hobbs has commented, '*Jubilee* was meant to be a punk world but it wasn't meant to be a punk movie, although everyone calls it that. We'd go round to the Rainbow and look at weird people and say would you like to be in a movie?' (author interview, London, 2000). Hobbs did not have a department for this film, but rather a helper whose job it was to paint the floors black. The texture created was absolutely of the moment, a postmodern pastiche of old and contemporary England. Images were positioned to deliberately clash with one another. The opening sequence, for example, an ornate country garden, a quintessential emblem of Englishness, leads into a grand room where Queen Elizabeth I is in conversation, and then cuts to a post-apocalyptic landscape of desolation, the England of the Silver Jubilee.

Likewise, *Trainspotting* delivered stark imagery that reflected and commented on the time of its creation. In a consumer-driven society the places inhabited by the characters revealed a distinct absence of 'things'. The drugs are the main characteristic of their dwellings, whether in bedsit, hotel or squat. There is little else in their possession. This creates a very unusual *mise-en-scène*, that works on a realistic and spiritual level of bankruptcy. They have nothing because all money is spent on drugs and anything they once had has been sold to pay for drugs so their lives revolve around the obtaining and taking of drugs in a relentless cycle. That is not to say that the absence of possessions equals an emotional or mental void, but it works as a visual cue in conjunction with other aspects of the design and the production as a whole. Indeed their consumption can be seen as a heightened image of capitalism. Much of the design operates on ground level, reminiscent of a tradition in Japanese cinema, where because the culture is lived on floor level the filming reflects this (for example sitting on the floor to eat, drink and socialise). There are mattresses on the floor, which continues the horizontal bias in the design.

The absence of many clues in the frame make it all the more interesting in its distillation of a period in time. How do the images work to give clues

about when this is? The colours used look retro in some respects, for example red and green are used in particularly vibrant ways that could evoke the 1960s or 1970s.

> [M]any of the scenes are designed and lit in such a way that they become artificially flattened ... through a heady mix of fish eyed lens shots, long shots and extreme close ups and the garish tropical beach scene that apparently covers one side of the interview room is typical of the way in which the backgrounds are used throughout the film to flatten scenes and accentuate their comic strip quality. (Lury 2000: 106)

After *Shallow Grave* (1994) and *Trainspotting*, Kave Quinn was requested to design commercials in a similar style. This in itself is an indication of the successful creation of a distinctive and memorable texture. Having produced a look that was much emulated, Quinn acknowledges her influences, including *A Matter of Life and Death* (1946), Ealing comedies and gangster films.

Even more contemporary, work for *EastEnders* takes place six weeks ahead of transmission and every episode is supposed to be a particular time. Anyone watching the show around recognisable times of year – Christmas, New Year, Valentine's Day, for example – will be made aware of this both by the plotlines and the props and dressing. The Christmas edition of 2001 was furnished with a huge Christmas tree in Albert Square, which later became strewn with party paraphernalia, including a nurse's uniform and bra come New Year's Day. This illustrates the time constraints that operate on a show that is intended to be set not only in the present but this week or even today. This is an interesting situation, especially when compared to film, which can be seen by anybody at any time; thus raising a temporal question to do with the relationship of production and consumption. At the same time there are advantages:

> If you are doing something like *Shakespeare In Love* [1998] you've got to research every little bit of timber work. Whereas today if you're going to do a contemporary interior you can go down to a DIY store and buy a door or a lock straight off the peg. (Laurence Williams, author interview, Elstree, 2000)

The lighting of much television output prevents detail and depth in the design, a result of high-key conventions. On live programmes this is particularly evident, where the creation of flat space is a recognisable standard. Daytime chat and magazine shows in particular adhere to an overlit collection of bright colours, coffee tables and sofas.

The use of videotape in the late 1950s meant that television shows could be pre-recorded, which revolutionised the design, now freed from the constraint of live broadcast. As Roy Christopher, designer on *Roseanne* has commented:

> Most sitcoms use a boxed set and all the cameras are usually on the fourth wall. With 'Roseanne' I tried to go halfway between film and a live tape setup. I took the sets and opened them up, turned them on a 90 degree angle so that you are now able to shoot clear from one end of the house all the way through into the other. Bit of a risk – careful not to shoot off the set into the audience. (1989: 34)

Programmes like *The Weakest Link, Who Wants To Be A Millionaire* and *Pop Idol* are futuristic, shiny arenas of blue and silver. Lots of metal stairs and walkways of unfinished materials give an impression of functional constructivism. Where are these places supposed to be and when? There is the sense of an arena in these game shows, where the contestants and the host/quiz-master are positioned in the centre under spotlights. The audience surrounds the competitors and is a strong point in the design concept – cheering and jeering them on is essence. No one loses their life in these arenas but their dignity and finances are at stake. This traditional design is given a high-tech appearance with shiny silver podiums and streamlined chairs; there is no detailing to distract from the essential functionality of the design, which highlights its purpose and the 'serious' nature of the game.

> Thus a design that depends on the illusion of contemporary reality will be more immediately convincing but will also date badly as the cultural environment around the design shifts in response to changing historical circumstance. Objects selected for their transparent resonance become opaque; those included as neutral filler find unexpected prominence within the obsessions of a new setting. (Tashiro 1998: 8)

The future

'Designs of the future can be divided into utopian or dystopian in their unerpinning conception. The surface design tends to fall into a limited set of styles, defined as futurism, retro futurism, realism, gothic and post apocalyptic' (King & Krzywinska 2000: 72–82).

The future implies difference, whether it is the antiseptic world of *2001: A Space Odyssey* (1968) or the cartoon of *Star Wars*. It provides the opportunity to explore the imagination, new worlds, people and ways of living – clearly design will be prominent.

Designing the future can be as fraught as both the past and the present, with integral problems that are similar around areas of representation and authenticity. For example, the 1924 science fiction film *Aelita* created a Martian world that looked pristine and desirable, while it was supposed to be organised in an oppressive and dictatorial fashion. Thus the design and narrative did not support each other. In contrast, *Metropolis* (1927) used the design to strengthen and add texture to the underpinning themes of the narrative. New York provided the model for the cinema's first city of the future in *Metropolis*. The design supports the concept of the film in highlighting the alienating and negative qualities of capitalism, through the avant-garde aesthetics of the early twentieth century.

Metropolis used a grid design to indicate the ordered, machine-like nature of the workplace. The decisions are a reflection of the themes of alienation and stratification that results from capitalism. There are elements of Russian constructivism in the imagery of cogs and stairways and the movement of the workers, while at the same time the skyline created is so stylised as to resemble cubist painting in its many planes. When Fritz Lang first arrived in New York harbour in 1924, he was irrevocably affected by the Manhattan skyline, which has been the inspiration for a wide range of films and television ever since.[10]

H.G. Wells adapted his novel *The Shape of Things to Come*, to be made a film in 1936, in which he attempted to create the antithesis of *Metropolis*. Being a science fiction writer, he had researched what the future would 'really' look like as opposed to what he termed the fanciful and flawed creations of Lang. He criticised *Metropolis* for its lack of authenticity. The stratification of the poor and the wealthy, he said, would not be represented in a vertical hierarchy as it had been in *Metropolis* but in a horizontal demarcation which had the poor in the city centres and the rich

in the suburbs. Wells' predictions were often correct but the film failed to gel for audiences. It may have been inaccurate but it is *Metropolis* that continues to capture viewer imagination through its iconic imagery.

When science fiction serials were created such as *Flash Gordon* and *Buck Rogers*, due to their low-budget nature some strange anomalies occurred in the design, such as retro Roman helmets and high-tech ray guns. These props were fused to create an eccentric look that became iconic of such shows, as did the blending of any style that seemed to say different or other. The postmodern collision of form and fashion continues to signify futuristic landscapes.

> Design styles are usually a good indicator of the period in which a film is made: *Flash Gordon* [1936] has the imprint of the 1930s, *Forbidden Planet* [1956] is instantly locatable in the 1950s, the costumes of *Logan's Run* [1976] are recognisably 1970s while the shapes and special effects of *Starship Troopers* [1997] are unmistakably 1990s. (King & Krywinska 2000: 72)

The British television series 'Dr Who' is responsible for conjuring up unforgettable images of the future according to a BBC budget. Dr Who travels across time, thus the designers of the show were responsible for representing the past, the present and the future. The constant in the design is the Doctor's TARDIS, which on the outside has the appearance of a telephone box and inside is a large control room/transportation device. This is a design joke in many ways, as discussed in chapter 2 – the exteriors of buildings are often matched to the interior studio creation, promoting the notion that the real exterior belongs to the construction. However, with the TARDIS no such matching is necessary – in fact the more uncharacteristic the interior is from the exterior the more successful the design – supporting the notion that the TARDIS is a device for time travelling, a fact which needs to be hidden and disguised by the innocuous outward appearance, which should fit in anywhere it lands without creating suspicion. Time is foregrounded in such a way in the programme that the texture of each period travelled to is accentuated to a heightened degree.

In *Blade Runner* the imagery of Mayan architecture inspired the two pyramids that house the Tyrell Corporation, who produce the replicants. A key concept for the design of the city was that of retro-fitting. This created a layered effect whereby each building has offshoots, as a result of upkeep

and repairs, that effectively gives the buildings an air of Frankenstein's monster – an eye, a nose, a mouth, all from different donors. Social status is again depicted through physical height, a boundary that is broken by the replicant played by Rutger Hauer when he goes to the top of the pyramid to meet his maker. Visual pleasure oozes from every frame: the creation of a highly textured *mise-en-scène* that is sumptuous in detail. We recognise references to periods past but this combination is new and stunning.

For the 1989 film *Batman*, the setting was created at Pinewood Studios, where a 400-metre set was created in five months. It is noted as the largest and most expensive outdoor set built in Europe since *Cleopatra* (1963). *Batman* has come to be respected as a visionary notion of an urban landscape of the future. It uses a combination of architectural styles, accentuating the gothic. Production designer Anton Furst was attempting to obscure both the time and the place of the setting, which is the inverse of most production design that seeks to clarify these and as such is an interesting project. 'It is no specific time period, just a pure piece of brutal expressionism which fitted into the timelessness of the movie' (Jones 1989: 58).

One way in which Furst approached this task was to mix architectural details – for example, the cathedral was created with both Antonio Gaudi's work and the house in *Psycho* (1960). Through the collision of styles a familiarity is apparent and yet it is new and intimidating to see. There is a strong temporal contrast provided in the two main locations; Batman's home is a historic country house while the city is postmodern. This choice suggests an underlying notion of the past as good and the future as sinister; the familiar versus the unknown, or tradition versus trend.

Thus, the two main strands of representation of the future are the utopian and the dystopian. The texture is either super-sleek and shiny or it is filthy, overpopulated and dingy. As underpinning ideas either technological advances create a better world or they dehumanise it, which results in the breakdown of society; texture is used to communicate these states in articulate, visually striking, ways.

Conclusion

During the days of the studio system, slavish fidelity to period detail was thought to produce confusion and boredom in audiences. If such décor seems far-fetched today we should keep

in mind that movies like religious art have reflected the tone of the times in which they were made. Regardless of the historical period in which a film is set, contemporary style seeps in. (Mandelbaum 1985: 142)

In terms of which films are remembered in a historical sense awards can be important. The selection of certain works over others could give us a collective false memory syndrome regarding what films were produced during that period. Typically it is design that does not have a contemporary setting – the past and the future receive acclaim. Initially this seems understandable, but when seminal design is ignored due to its contemporary setting there appears to be a fundamental misconception around the recognition of accomplished design that is self-perpetuating.[11]

It is time somebody changed it. It is fostered by the American Academy because it's only 200 years old there is that obsession with history and heritage. There is this notion that period films represent more effort, more work and more talent than contemporary which is nonsense. (Craig, author interview, Windsor, 2000)

The following and final chapter considers the ways in which changing technology has influenced the texture of the screen image.

5 THE ROLE OF TECHNOLOGY

Changing technology is responsible for transforming cinema and television, often leading to new and exciting forms within these media. Fundamental developments like sound and colour have had a dramatic impact, while lighting and camera equipment's increasing sophistication continually nudge the medium in new directions. For example, it is as a result of advances in different technologies that the pendulum has swung in and out of doors to such a degree: moving in with artificial light, moving out with portable cameras and advanced film stock, and back in to compete with television.

This chapter will look at the impact of expanding technologies on film and television and explore how they have influenced the design process and product. The drawing board remains the starting point for much art department *drafting** but CAD is also used, which enables someone without the traditional technical skills to design in 3D. Thus the process is altered but in what way is the end product influenced? Computer technology is sometimes criticised for taking away the creativity originally involved in production design. Is this the case, or is it simply that the tools are different? There have always been tricks of the trade – what were they in the past and how have they modified? What are the implications of portions of sets existing only as digital creations, and is this any less authentic than the old techniques of glass painting?

'The development of cinema technologies over the past four decades has been the result of a complex interaction between industrial needs, product differentiation, economics and audience expectation' (Allen 1998: 109). In order to assess whether expanding technologies are advancing

screen design, let us look at a range that have been developed and consider their impact on the screen image and, more specifically, the designer.

Technical drawing

Computer Aided Design is a package that enables the drafting of three-dimensional drawings. It can be much speedier than the traditional method of technical drawing, which takes place on a drawing board by hand using old-fashioned tools like rulers and T-squares. The main way that this new tool may be seen to change the end product is that it can take less time to produce. The computer does not originate the architecture, the measurements, or any other creative aspects of the activity – it merely regurgitates what it has been fed.

Sound

With the addition of sound to the screen image came new possibilities to enrich the medium. There were also new complications, as Leon Barsacq points out:

> [A]t the beginning of the talkies, the sound engineers acquired considerable importance. Every time the sets were changed, the sound engineer in charge would appear with an air of consternation, clap his hands, cock his head, listen to an imaginary echo and declare bluntly that it was impossible to film in that set. (1976: 158)

The above account conjures up a vivid scene and goes some way to suggest how sound might influence the way a set was designed and built. The positioning of fixtures such as windows and doors and the choice of materials used would have to take into consideration the acoustic effect they created. The introduction of sound made filming on location more problematic; back in the studio, new techniques to create the illusion of exteriors were developed as a direct response to this impediment.

Diegetic sound also became important, in that props that were part of the narrative would have to sound realistic, therefore could not be made of papier mâché if they were supposed to be wooden, for example. In the

same way, sound could add to the texture of the picture, enhancing or implying elements that it would be too costly to actually put on screen. For example, in *Honey, I Shrunk the Kids* (1989), sounds were amplified to assist in the play on size between the shrunken and the now apparent enormity of the real world.

On *Cold Lazarus* (1996), Christopher Hobbs was keen to work in conjunction with the sound design to ensure his work and theirs was in unison: 'Talk to the sound engineer about how sound would bring our city to life. Thank goodness he seems to understand how much sound would strengthen the imagery, especially the effects' (in Petrie 1996: 132).

Today the role of sound is fundamental as it helps to immerse the audience in the screen experience.

Colour

The use of colour in film and television enhances the image, giving added depth and nuance to plot and character and providing further visual interest; thus it is a useful additional tool in the designer's kit.

The psychological effect of colour is an important aspect when designing. The choice of colour is not arbitrary. Some colours signify danger or excitement (red), while others imply death (black, purple, white), and so on – a colour code is built up which adds depth of meaning to the image on the screen. There have been many studies into the use of colour in this sense and specifically in relation to film. Sergei Eisenstein wrote 'Notes of a Film Director' in 1948, where he considered the different meanings associated with the spectrum of colours.

> The first colour films were the hand tinted frames used in Méliès' *A Trip to the Moon* (1902) and *20,000 Leagues Under the Sea* (1907). These frames were coloured frame by frame by women factory workers, each of whom brushed on a separate colour. (Barsacq 1976: 154)

As with the majority of new technology there was a race for control of the market. *Becky Sharp* (1935) was the first Hollywood feature to use the Technicolor three-strip camera. The Kodachrome process also came out that year, which was revolutionary because it was photographed on one film (three layers of emulsion on one base), which made the operation

more flexible. An agreement was made between Technicolor and Kodak to combine the two techniques; by filming on Kodak and printing with Technicolor the strengths of both systems were utilised. Eastmancolor became the leading process, because of its advanced sensitivity.

The method resulted in some unpredictable side effects; although it needed less light it exaggerated certain colours – blue was particularly problematic and had to be substituted with grey. Similarly beige was used when grey was required. The outcome was distinctive of the period, producing films with almost entirely beige settings. A limited palette, although restricting, actually provided creative opportunities with, for example, the choice of certain key colours that could not fail to stand out amid the sea of neutrality. 'We even had to spray yellow the leaves of the real trees, in order to tone down their crude green' (Barsacq 1976: 158).

This is a technique that has been used since for stylistic rather than technical purposes. For example, in *The Red Desert* (1964), the grass was painted to tie in with the colour scheme, and in *Blow Up* (1966) existing exteriors and interiors were repainted. Today, different film stocks are available to enable the film-maker to manipulate colour in a similar way. *U Turn* (1997) used cross-processed 5239 reversal film, to create a highly saturated, unnatural look that made primary colours glow in a similar way to the primitive film stock of old. In the early stages of colour, consultants would act as the experts in the field dictating exactly what was acceptable, from make up to lighting and paint choices; a process that has been criticised as producing a dull and homogenous rash of films that failed to capture the possibilities that colour afforded.

A Matter of Life and Death's (1946) combined use of both colour and black and white sequences was intriguing and signalled the now integral nature of colour in the film-making process. Films started being conceived in terms of palette and it became part of screen language. Imagine *Amelie* (2001) or *Moulin Rouge* (2001) today in black and white. Much of the mood, sense of place, and character would be lost because these films rely on selection and combination of colour to help tell their stories.

Cameras, stock and formats

Different stock can provide a range of effects – grain, for instance, contrast, tone and colour. Newer, faster film stock has impacted on set design, as Lawrence G. Paull explains in relation to his work on *Project X* (1987):

That corridor is almost 170 feet long and I forced the perspective to make it seem even longer. Yet it was lit with overhead lights that are part of the set. If we didn't have the fast film we would have been building flats and putting scaffolds around and lighting them from above. (in Turner 1987: 56)

In television, the perfection of videotape in the 1950s lessened the necessity of shooting everything live. Pre-recording provided new and exciting territory, whereby settings escaped the theatrical conditions imposed. Having said that, television shows with a live audience remain closer to the theatre in their design, as a result of the restrictions of presenting to one position.

Initially designers had to be extremely sensitive to the limitations of the technology, using a *grey scale** to avoid extreme tonal contrasts. The result was a limited range of colours that would then be over-lit. The advances in camera, tape and lighting has opened up the field for designers. The impetus after these constraints was understandably toward realism.

Lenses

Depth of field varies depending on the lens used. The greater the depth of field the more layers it is possible to create within the frame. With a shallow depth of field, the design tends to exist on one plane, but with deep focus there is the possibility of dynamic design that operates from front to back as well as on the immediate foreground. *Citizen Kane* (1941) exemplifies this with its articulate control of spatial depth defining mood and character.

Revolutionary ways of supporting and moving the camera have influenced design in that the relation of the camera to the setting can change quite dramatically. For example, tracks, cranes and Steadicams all allow the fluid movement of the camera, which can scrutinise the set from a range of positions. In the same way that the first tentative motions of the camera forced the adaptation of the painted backdrop into constructed scenery, these continued developments require close attention to detail.

Widescreen

Since the beginning of cinema there have been a diversity of screen ratios promoted, the use of which were finally embraced to help differentiate

from television. The difference was expanded in direct competition with television, which is now of course a major outlet for the screening of film.

Cinerama, originally developed by Fred Waller in 1939, eventually reached the screens in 1952, with *This is Cinerama*. It was not actually employed on a feature film until *How The West Was Won* in 1962. The width created technical problems in that there were distortions that made close-ups unfeasible and camera movement problematic.[1]

'For big exhibitors, CinemaScope was the answer to a dream, enabling them to present a seductive big screen spectacular event for which they could charge more money at the box office.' (Allen 1998: 112)

The broadcast of film on television has been problematic in the deviation between the proportions of the cinema and television screen. The issues around the composition and what we do and do not see in each of these different formats is a continuing area of debate.

How to Marry a Millionaire (1953) became the first widescreen film to be shown on television in America, in 1961. This is where 'panning and scanning' began, where sections of the widescreen scene are selected and transmitted as full television screen images, thus completely changing the frame from the original. The process impacts on the designer, as their work is effectively re-edited. The entire geography of the space is transformed, changing volumes and spatial dimensions on a fundamental level. 'It thus re-composes films made in and for widescreen formats in at least three different ways: by reframing shots, by re-editing sequences and shots and by altering the pattern of still and moving shots used in the original film' (Neale & Smith 1998: 131).

What is lost in translation could be important in terms of character, narrative and compositional balance. Steve Neale and Murray Smith consider how films began to be composed with dual screening in mind and suggest that both of these are framed with the full use of widescreen. However, they go on to list the missing elements in the panned and scanned version of *Chinatown* (1974):

...the car immobilised by lack of water in the street outside the barber's shop, the water dispenser in Gittes' office, visible on the left hand side of the frame in the shot in which the real Evelyn Mulwray (Faye Dunaway) makes her first appearance, the image of the fish on the wall in Hollis Mulwray's office, and the vase of

flowers on the left hand side of the desk in Mulwray's secretary's office. (1998: 134)

They conclude that the film seems to have been set up with both formats in mind, in that the information that is lost when panned and scanned reveals a new scene which is equally well composed, a frame within a frame if you like. However, even the loss of what Neale and Smith call 'inert background décor' is influential, because it is not only objects in space but also the volume of space itself that are intentionally designed, thus suggesting that each format is different and should be viewed as such.

Novelty

3D premiered in 1952, with *Bwana Devil*. Spectators wore Polaroid viewers, to separate the two images into one eye each, which created a 3D effect in the brain. The novelty lasted about a year before fading into obscurity. IMAX (1967) and OMNIMAX (1973) were both developed to extend the image beyond the field of human vision, thus enveloping the audience. These experiments created unique design options, where the ideas of depth and immersion can be highlighted to intensify the overall impact.

Special effects

The term is used increasingly in relation to cinema, where the audience seem hungry for flashy effects. However, what is understood by the expression? These days we tend to mean *computer generated imagery**, but special effects have been utilised on screen from the beginning of cinema, where an ingenious range of methods have been employed to further audience entertainment. Earlier effects fall into two types: visual effects, that is special photographic processes, and mechanical effects, categorised as either mechanical or optical.

Special effects have been used since the very first films, when Méliès' designer-painters would move scenery such as the sun, moon, waves, trains and cars to create the effect of place or motion. These simple techniques evolved into more sophisticated ones in the form of reduced scale models. Models, glass shots, matte shots, rear and front projection all form the traditional gamut of special effects.

Models

The three-dimensional model came into use in 1924, which as well as adding depth to the image allowed camera movement through the use of a platform that attached to the camera. The lighting of models can be problematic in terms of matching the scaled-down lighting with the real set lighting. Whether it is *Ben Hur* (1925), *Metropolis* (1926) or *Cold Lazarus* (1996), miniatures have added to the design in depth and atmosphere.

The Schufftan process uses models and combines live action with reflected miniatures. Scale models are reflected onto mirrored glass, which is arranged at a 45 degree angle to the camera. Sections of the mirror are scraped away to reveal portions of the real set where the live action takes place, thus combining the real and the scale model in one interwoven frame. The method was first used by Fritz Lang in *Die Niebelungen* (1924) and again in *Metropolis*.

So the use of scale models really gives a huge amount of scope to the designer. However, there are drawbacks. The larger the model the more it ties in with the built set and the greater detail can be included. Elements like water, fire and smoke do not adapt well to scaling down. As Barsacq puts it, 'A slight ripple, enlarged even fifty times will never possess the majestic motion of a wave, just as a cigarette does not smoke like a factory chimney' (1976: 188).[2]

One of the main advantages of models is to save building large sets. Generally the main advantage of much special effects work is to save time and money. Douglas Trumbull pioneered the system of motion control for *2001: A Space Odyssey* (1968), shooting static models of flying machines with a camera that made repeated passes on a precisely controlled path. *Blade Runner* (1982) used this system also on a model (1.2 by 1.7 metres), which was filmed in a smoke studio, where diesel fuel was used to create the illusion of a polluted atmosphere.

Hobbs uses another model technique combined with a water tank:
The effect I have developed of building underwater models and shooting them through Dettol in order to give them atmospheric haze. The advantages are considerable in that the water acts as a lens and the depth of field is much better, meaning we can use smaller models. (Petrie 1996: 131)

The optical printer

This piece of equipment works in a similar way to a film projector but projects images onto an unused negative. A process camera holds the dupe negative and a projector the master positive. The machinery is synchronised to render a frame of positive and one of negative together, thus allowing a combination of real, constructed, models and painted backdrops to be layered, effectively manipulating what is in the shot beyond practical and physical restrictions. For example, the foreground may be built while the background is painted, which has both aesthetic and cost implications. As already mentioned the costs are limited when everything does not have to be built. The technique was used in *Citizen Kane* (1941), where estimates suggest that half of the film was optically manipulated.

Perspective

Sets are often constructed in false perspective so as to give a greater distance effect than is actually available, for example by scaling down the size of aspects towards the background. For this to be visually acceptable the vanishing point must be calculated and props need to be on a similar scale. In the case of actors, sometimes it is necessary to use children in the distance to stay true to the scale.

Paintings or photographs of exteriors can be fixed outside of windows or doors to substantiate the impression of place (see chapter 2). For increased authenticity these can be layered to further the impression of three dimensions.

Matte and glass paintings

As early as *The Great Train Robbery* (1903) an in-the-camera matte was used, where a train can be seen through the office window. Jean Perrier developed the process initiated by Norman O. Dawn and later Ferdinand P. Earle, that involved painting part of the set on a plate of glass and filming it in conjunction with a section of built set. The process also became possible on cardboard, which saved time and money. Having said this the operation requires several hours in order to adjust lighting on the set and the painting.

Building on this idea Charles Assola introduced the use of a matte, which was a silhouette of the section to be painted, thus photographing the existing portion of set without exposing the section to be painted. A counter matte protected the already exposed area while the painting was photographed, thus enabling the combination of action and sequence. It also means that buildings can be rebuilt or altered. A structure that is now in ruins can be restored to its former glory with the aid of a painted glass shot.[3] The technique is essential where special effects of large-scale destruction are required but has also been used to create unique settings and to avoid going on location. When the boat crossed the bay in *The Birds* (1963), that was a matte. Although it was a straightforward set up it was often felt it was easier to paint it on glass than to set the shot up on location (a notion that ties into ideas discussed in chapter 2 in relation to the relative merits of studio/location shooting).

> Norman Reynolds did it for *The Empire Strikes Back* [1980] to show Han Solo walking up to the Millennium Falcon. Audiences thought they saw a vast hall full of futuristic armaments, but all of it except the centre of the frame was a painting. (Mills 1982: 46)

The original *Star Wars* made extensive use of models and matte painting, in conjunction with live action. These compare favourably to the recent episodes criticised for overuse of flat and soulless computer generated imagery.

Another way of combining studio with footage shot elsewhere was the Dunning process, which used *blue screen** methods still employed today; again enabling the manipulation of indoor and outdoor shooting together to form one image. In the case of rear projection the landscape is filmed from a moving vehicle, thus presenting the view from a car, train or boat, which can then be projected from behind onto a screen with the relevant vehicle positioned in front. As discussed in chapter 4 the image of a 1940s car journey is incomplete without the now obvious-looking projection of the scenery behind. The technique was preferential to the problems inherent at the time with location shooting but film-makers today have enjoyed making deliberate use of it with postmodern irony.[4]

Weather effects from a light drizzle to an earthquake were created through simple methods:

Rain comes from sets of pierced copper tubes, fire hoses, vaporisers and the like which control the amount of rainfall from a fine drizzle to a downpour. Fans of various types even airplane propellers or a wind tunnel are used for wind effects. Lightning is obtained by rapidly switching on and off naked arcs. Window panes are frosted with yellow soap or liquid glue, squirted on. For some years, small aerosol bombs have been used to frost or dull shiny surfaces. Borax, fibreglass, cotton wool, white sand or plastics such as polyesters produce different snow effects ... Artificial fog and heavy smoke are created with an ingenious apparatus using paraffin and ice ... Parts of the set, arranged in advance, come crashing down, pulled by invisible threads of fine steel or nylon. Rocks or beams that fall on the actors are made of cork or light balsa wood ... windows, bottles and glasses broken in the course of the action are made from a sugar base or plastic. (Barsacq 1976: 191)

These methods were to varying degrees successful but can look incredibly dated and unrealistic today in the face of the digital technology that is now employed to create the majority of special effects.

Computer generated imagery

Undoubtedly, in the future more and more elements of a film will be computer generated. The designer will have to be able to add the computer to his working tools but also the schedule will have to be amended, either so that more effects shots are created during shooting, or so that the designer continues working on the film in post production. (Craig, author interview, Windsor, 2000)

Many designers seem to think the computer provides further possibilities when combined with more traditional methods. As Anna Asp says, 'On a personal level though it doesn't really interest me. I like to work in three dimensions, I like the physicality of a set or a model. I like to be able to reach out and touch it' (in Ettedgui 1999: 119).

As we have seen, in the past matte paintings were embraced as part of the design process, so why should the use of more advanced technology in the form of computers present a problem? The debate tends to focus on

the distinct artificiality of the computer effects and their prominence at the expense of the narrative. *Star Wars Episode II: Attack of the Clones* (2002) has been particularly criticised for an overuse of effects that defy realism in fundamental principles like gravity and movement. A symptom of the extensive use of blue screen is wooden performances from actors who are simulating responses to effects.

'It's partly that, despite the millions of dollars spent on developing software that gives computer generated imagery the textured, sinewy appearance of real life, many of the CG creations still look about as real as a £3 note' (Levy 2002: 20).

The technology now making such creations possible has been in development for some time. In 1973, Information International Inc (triple-I) created Yul Brynner's robot vision for *Westworld* (1973), a mosaic effect. The same company created a synthetic head for Peter Fonda in *Futureworld* (1976). The computer generated figures in *Toy Story* (1996) began as real-world 3D objects, whose contours were scanned and the co-ordinates fed into a computer which could then use the statistics to generate a cybernetic replica (see Allen 1998: 123). These simple techniques slowly increased in sophistication.

Flash Gordon (1980) signalled the arrival of compositing, an electronic version of the technique previously achieved, using optical methods in a studio's processing laboratory, in which two separate images are combined to form a new original (see Allen 1998: 124).

The breakthrough for digital morphing came in 1991, with *Terminator 2: Judgment Day*, when it became clear that such effects were capable of large returns at the box office. Traditional backups were set up for every effect in the film in case the computer technique did not work.

These advanced special effects are put to use largely for the purposes of the science fiction and disaster genres. Film images in the late 1990s offered cities under destruction and a range of famous buildings were totalled. In *Armageddon* (1998) it is the Chrysler building and Grand Central station. The apparent realism of these images, compared to attempts toward this in the past, is impressive. Technically, getting these landmarks to look like the real thing as they burn, crumble and flood is an opportunity to show off effects expertise. So the use of somewhere universally recognisable such as the Empire State Building or the Eiffel Tower has more resonance than a big, impressive, unknown building. The vast destruction in films like *Deep Impact* (1998) or *Armageddon* can be

seen as a continuation from a tradition that takes in epic disasters such as *Intolerance* (1915). Thus from one point of view the inclusion of a disaster scene can tell us much about the cutting edge technology of the time while enriching the overall production values.

Also, in science fiction, the effects are essential in assisting the narrative in the notion of the future. Therefore the constant advances in the technology that makes special effects all the more 'special' is fundamental to the creation of a screen image in line with the concept of its inception. However, the visual dominance of special effects is often criticised for detracting from the story or the characters in some way, when they are there primarily to support these elements. Geoff King suggests that the spectacle does not necessarily negate the narrative: 'Even if the spectacle comes first, in the economic and aesthetic calculation ... these films retain significant investments in narrative structure, in terms of both story construction and underlying dynamics' (2000: 161).

It is worth noting that the 'cinema of attractions' of early film predates narrative-driven cinema, where visual spectacle was privileged over plot development.

In *Harry Potter and the Philosopher's Stone* (2001) the story relies on magic. Therefore it is imperative to demonstrate supernatural acts performed in support of the characters and narrative. Flying, slaying monsters, and the levitation of objects are all essential, and this is an example of story and effects working together. Part of the pleasure springs from our witnessing Harry develop his powers from accidental revenge (his stepbrother trapped in the snake pit) to controlled and skilful supernatural prowess (the quidditch game). The strengthening of his magic is essential to the character and plot development. For example, the scene at platform 9¾ at Kings Cross station, involving walking into and through a concrete column, demonstrates Harry's early doubts and apprehension about his magical ability. Scenes like these also work in terms of keeping the character in the setting, with the apparent solidity of the column. There is a sense of realism attached that is lacking in films like *Star Wars Episode II*.

'You can't help noticing that certain CG effects seem to operate independently from the bounded reality of the environment described' (Levy 2001: 22).

Thus contemporary special effects do receive criticism, the majority of which is reserved for films that tend to have an over-reliance on the effect without contextualising in terms of overall production concerns.

Painting versus realism

With the inception of colour came comparisons to paintings and painters. Barsacq dismisses these ideas quite vigorously:

> However little anyone knows about films and painting, it is obvious that to compare a film with an easel painting is absurd. Since the actors, sets and furniture possess volume with some parts lit up and others in shadow, all flat areas of pure colour, so familiar to painters, must be ruled out. It is pointless to talk about a Cezanne, a Breughel or a Delacriox of the screen: painting is static and film is above all a dramatic progression. (1976: 156)

Today high-definition digital cameras are being used increasingly. The images are produced more cheaply than film, enable a greater depth of field, and have an increased capacity for subsequent manipulation. For example *Vidocq* (2001) had around a third of its scenes enhanced in post-production. The system allows the film-maker to continue working on the images in what has been termed a painterly fashion. This is the same technology that George Lucas has been developing with Sony and Panasonic for his latest, *Star Wars Episode II*, which took three months to shoot and eighteen in post-production. Most cinemas do not have the technology to screen these films, however, which means they will have to be scanned on to 35mm film for exhibition. There are parallels between this and viewing a film shot for the cinema on a television screen.

Raymond Durgnat has noted, 'With films like *Diva* [1981] and *Days of Heaven* borrowing techniques from painters, suddenly the scenery is the star' (1983: 41). A comparison may be identified in the evolution of special effects to painting at the stage where realistic representation was achieved in a photographic sense, thus allowing movement into the use of less literal, more expressive, forms. 'All these movies scrutinise their settings with a painterly intensity. They dissolve the conventional distinction between photography (realistic) and painting (artificial)' (Durgnat 1983: 42).

The more advanced the technology, the more the idea of realism can be achieved and evoked. In terms of design and stylisation the older techniques created distinctive looks that simply could not capture realism for the modern audience. The strength of the glass paintings in *Black*

Narcissus (1947) is not physical authenticity but emotional resonance. Here, a cinematic place is created using paint and glass, which is its breathtaking beauty – it is not a replica of real mountain locations.

Backgrounds, buildings, and so forth can now be created digitally and added to the scene, whereas previously this was done with matte and glass painting. What are the essential differences? The skyline through the window in *Rope* (1948) is blatantly artificial, a painting. Is this any more or less 'authentic' than the digitally produced *AI Artificial Intelligence* (2001) skylines? Which is more resonant – or, for that matter, realistic?

> The intention of all technical systems developed since the beginning of the 1950s has been towards reducing the spectators' sense of their real world and replacing it with a fully believable artificial one. (Allen 2000: 127)

While making the point that these films pride themselves on the realism of their effects (invisible, seamless) there is a dichotomy whereby we are expected to be impressed and to recognise these effects when they appear on screen. *The Matrix* (1999), for example, plays on ideas around appearance and authenticity through the representation of an alternative reality that reduces popular conception to digital coding.

For Richard MacDonald, production design is like playing God, or painting. 'The weather, architecture, atmosphere, period in time, time of day, the composition which goes beyond town planning to something universal. And you begin to get the picture' (in Mills 1982: 42).

The portrayal of technology

The evil of scientific advance is quite often cast against the goodness of nature. It is ironic that this narrative is being told not through word of mouth but through technology. There is a contradiction that exists between screen technique and underpinning ideologies.

> Special effects-laden films like *Jurassic Park* and *Titanic* are, at one level, celebrations of the capacities of cinematic technology, even while their narrative dynamics often question the role of technology. The enjoyment of special effects lies, perhaps, in allowing ourselves to be deceived. (King 2000: 56)

As far as the narrative is concerned the problem is often not technology but the uses it is put to. This could also be said for the design technology, from the use of matte painting and rear projection to CGI, which can be used in creative ways that enrich the production or as cheap tricks that draw attention to themselves.

Comparisons with musicals abound, in that the apparent disruption of the musical number actually contributes to the plot, in some way progressing it. Special effects moments may operate in a similar way, and without them perhaps something would be missing. Also the focus on these 'disruptive' moments can render the rest of the film as natural rather than a construction.

Another argument is that special effects expertise is rendering the job of the designer redundant. This is an oversimplification as technology is the tool, which is superfluous without the concept that the designer is responsible for establishing. Thus the choice of equipment available in realising the designer's work has evolved and they with it. It is, as ever, the ways in which these techniques are employed and manipulated that create the potential to produce intriguing work, not the machinery itself.

With each new development in technology there seems to be a panic about the old traditions and artisans becoming lost. Rather it seems to be the case that each development builds on and enriches the existing practice of cinematic illusion. It is technology that enables the telling of screen stories and as such it has always influenced the process and end product. Through a continued manipulation of current methods, strong images are produced and remain with us. It is not making use of these that would detract from design. Film began as a visual medium and this is easy to forget today, especially with work that has an over-reliance on dialogue.

As Bart Mills asserts, 'the kind of films that attract the best PDs are "very visual". This tautology refers specifically to action pictures set in exotic locales. When a director is preparing a very visual film, virtually the first man he hires is the PD' (1982: 41).

Conclusion

The focus is on spectacle as spectacle rather than as something subordinated to a place within a narrative structure ... spectacle tends to be foregrounded especially during periods of innovation

such as the initial use of sound, colour, widescreen or computer generated technology. (King 2000: 31)

So, are visual display and narrative drive engaged forever in battle or are they able to collaborate in the production of memorable imagery? Whether it is the tidal wave of *Deep Impact* or the parting of the Red Sea in *The Ten Commandments* (1923), special effects have been key to awe-inspiring imagery. Thus the inclusion of effects has resulted in haunting and evocative designs that combine techniques both old and new in the support of the narrative.

'The huge commercial success of *Star Wars* marked the start of a sustained boom in Hollywood science fiction, the centrality of which can be explained in terms of both narrative and spectacle' (Allen 2000: 70).

Technology has enhanced and enabled design to expand its boundaries, crossing between realism and artifice. A key offshoot of which is the problematic of style over content, as exemplified in debates around contemporary special effects, highlighted in the recent *Star Wars Episode II*, where it is argued that the extreme artificiality of the sets and effects empties out the meaning, leaving nothing but the super-sleek surface of its computer creation.

Through this discussion we have seen the continued evolution of the production designer in response to changing technology. However, their role has remained rooted in the early inception of art direction, as Beverly Heisner puts it:

Art direction is a branch of architecture in which environments are built but seldom in their entirety and seldom to last. What the art director creates are spaces, facades and even entire towns ... Beyond that the art director, using only fragments of nature or architecture or manmade objects, can evoke mood, establish themes and etch characters in films. (1990: 1)

Thus the production designer continues to employ this 'branch of architecture' to create worlds on the screen that innovate and inspire.

NOTES

Chapter One

1 See Paul Rotha (1928) 'Artists Behind the Film Technique of the Art Director', *Film Weekly*, 4, 16. According to this article the art director must possess: a deep appreciation of line, form, proportion and composition; knowledge of architecture in all its branches; an expert understanding of camera angles and perspectives; knowledge of colours and their photographic values under *panchromatic** and ordinary stock; a working knowledge of lighting and the use of light and shade and tone values; a definite knowledge of such sidelines as furniture, pictures, costume design, materials etc and competence to design any of these if necessary; a practical experience of plaster work, carpentry, painting, varnishing, stone work, joinery etc.

2 Robert Mallet Stevens was a designer who studied camera angles which vary according to the focus of the lens used. This was later developed into an equation which determined precisely how much of the set would be seen and therefore built, using a particular lens at a particular angle.

3 Today 10 per cent of the overall budget is the usual amount allocated to the art department, so it has been chipped away a little.

4 In 1937 Edward Carrick established the first school for the study of film as an art, followed by the first textbook on *Designing for Moving Pictures*. The Society of British Film Art Directors and Designers was formed in 1946.

5 'I feel that our sets always look exactly what they are – sets that have been put up a few hours before, instead of seeming in their aging and in their dressing to be rooms that have existed for some time and that have been lived in.' 'The Greystone Seminar', *American Film*, 1977, 2, 4, 17.

6 Probably the most famous project done by film designers outside of film is Disneyland. Walt Disney used his staff art directors to help conceptualise and lay out his parks (see Newberry 1989: 36).

7 *Moulin Rouge* won the Academy Award for Best Production Design in 2002.

Chapter Two

1 There are exceptions to this need for windows and doors. *Gone to Earth* (1950), for example, was designed without any; instead the characters come in and go out by the camera.

Chapter Three

1 Art director John De Cuir fought with director Walter Lang on *The King and I* (1956). Lang

had a heart attack and De Cuir received an Academy Award.

2 Examples of director/designer collaborations: Ferdinando Scarfiotti and Bernardo Bertolucci; George Cukor and Harry Horner ('George would say Harry you set up the camera' (Homer in Thomson 1977: 34)); Richard Sylbert and Mike Nichols; Henry Bumstead and Clint Eastwood ('Clint Eastwood embarrasses me by arriving on set and saying where do you want me to put the camera?' (Bumstead in Ettedgui 1999: 20)); Wynn Thomas and Spike Lee; Jean Renoir and Eugene Lourie; Marcel Carné and Alexander Trauner; John Ford and James Basheri.

3 It took Christopher Hobbs three weeks to paint twelve paintings in the style of Caravaggio.

4 The camera lens sees a 4 x 3 shaped wedge of the scene. In a zoom lens this can be varied from narrow (10°) to wide (50°). The lens angle can be drawn on scale plans to show what a camera will see from any given position. The vertical lens angle is three quarters of its corresponding horizontal angle and can be used on scale elevations.

5 It is said that the German production designer and director, Paul Leni, who fled from the Nazis to America, in desperation at not being able to speak English, virtuously made up so many roughs that from them the first storyboards came about – probably a rather romanticised version (see Ludi 2000: 24).

Chapter Four

1 Another unusual approach to the representation of the past can be found in Olivier's *Henry V* (1944), where the designer, Paul Sherriff, employed false perspectives for the interiors and the furniture, as they appear in fifteenth-century miniatures. The elements of the sets are reduced in scale so that the characters clearly dominate, referencing the principles of the French primitive paintings, and reminding us that perspective is just another visual convention.

2 Two films that have used the skyline in interesting ways are *Street Scene* (1931) and *Dead End* (1937).

3 *A Life Less Ordinary* used this for heaven.

4 Arc lighting was replaced with incandescent lighting, which made a white set possible where it had previously been painted pink or green to avoid dazzling the audience with a bleached out picture.

5 Interior decoration magazines covered these designs with enthusiasm, being much more comfortable with these than the previous ultramodern look of the studio.

6 It did, however, seem to influence the Emerald City in *The Wizard of Oz* (1939) with its utopian imagery. This link with film sets and world fairs has been commented upon in terms of their common aim to entertain and inspire for a limited period of time.

7 Minelli was an art director before becoming a director.

8 Baz Luhrmann plans to produce *Moulin Rouge* for the stage, which is part of a current trend in adapting films for the theatre.

9 *Playtime* (1967) is mainly a film about modern architecture and technology; it plays with images of modern architecture suggesting it to be confusing and ultimately unpleasant to live in. Tativille was created on a lot outside Paris, with models that could be moved on rails. This temporary city used 50,000 cubic metres of concrete, 3,200 square metres of carpentry, and 1,200 square metres of glass. The homogenous nature of modern architecture is also criticised.

10 A landmark that was as visually distinct as it was metaphorically resonant has now gone. Since 11 September 2001 the World Trade twin towers are no longer a part of the Manhattan skyline. This will be very much an image that clearly identifies when a film was made i.e. pre- or post-11 September 2001.

11 Nearly half of the nominations for Academy Awards and three fifths of the winners are period films but period films are much less significant in the Best Picture List.

Chapter Five

1 The first cinerama screens had a curve depth of over 16ft and had a 146 degree (horizon-

tal) by 55 degree (vertical) field of vision.

2　In relation to the problems inherent in the old method, Allen's contemporary discussion indicates the progression in special effects. 'The detail and texture in all this is highly impressive, tiny human figures spiralling to their death and even the water – along with fire, a traditional bugbear of special effects – appears to maintain appropriate scale' (Allen 2000: 50).

3　In *Samson and Delilah* (1949) Samson destroys a temple and brings a giant idol down on to a crowd of people. The idol was a 17-foot model which looked over 100 feet tall and the actors it crashed down on had been matted into the shot.

4　Rear projection was invented in the US. Paramount's Farciot Edouart was considered the master of the technique (see Barsacq 1976).

GLOSSARY

ageing – creating the effect of the passage of time on surfaces/objects.

art department – the team who work under the supervision of the production designer. Includes art director, set decorator, scenic artist and property master.

art director – previously the head of the art department, now the person who works directly beneath the production designer, executing the designing of the sets.

aspect ratio – the ratio of width to height of the screen image.

backdrop/backing – painting or photograph used as background in a set.

back lot – the outdoor studio area where exterior sets are built.

bauhaus – a strong design style developed in Germany.

blocking – the process of plotting the actors' positions in relation to the set and the camera.

blue screen – a special effect where a scene is shot in front of a blue screen which will later be replaced with the desired location.

CAD – Computer-Aided Design. Software that produces technical plans and elevations.

CGI – computer-generated imagery.

chiaroscuro – lighting design using strong contrast of light and shade, associated with German Expressionism and Film Noir.

close up – shot size indicating the head of the actor.

composite set – a set featuring several spaces through which a sequence of action unfolds.

construction – the building of the set.

construction crew – the group of craftspeople who build a set, including plasterer. carpenters, painters, riggers.

cyclorama – a curved seamless backdrop.

director of photography – head of the camera department, responsible for lighting and framing each shot. Also known as the Cinematographer.

drafting – the drawing up of technical plans.

dressing – the arrangement of furnishings, props etc within the set.

elevation – scale drawing of a set made in projection on a vertical plane.

forced perspective – a technique used to give the illusion of depth. The scale is cheated.

freelance – a system of employment prevalent in contemporary film and television industry whereby individuals are self employed starting a new contract each new production.

grey scale – a graduation of tones from black to white.

kitchen sink – term associated with British Social Realism.

location – any outdoor or indoor setting found in the real world and adapted to provide the setting for the production.

location manager – sources suitable locations for filming.

long shot – a shot size indicating full body shot.

matte painting – background painting which is composited with foreground live-action shot separately.

miniature – a scale model of a large set which is combined optically with live-action footage of the actors to create the finished image.

mise-en-scène – the selection and composition of elements in the frame.

model – a scale model of the sets to be constructed used in pre-production. A model used in shooting.

panchromatic – film which responds to all the colours of the visible spectrum.

perspective – the illusion of three dimensions created in two, like the canvas of a painting or a cinema screen.

plan – scale drawing of a set as viewed overhead.

production designer – head of art department, responsible for giving a film or television production a visual concept.

production values – a term used to indicate the degree of time and money employed in a production and thus represented on the screen.

props – properties in the set.

prop buyer – obtains the props.

props dresser – positions props in a set prior to shooting.

prop master – responsible for all props.

props stand-by – is on hand to reposition props as shooting goes on.

scene – a self-contained unit of action that takes place in one setting.

scenic artist – paints scenic backdrops.

scenic painting – a large scale painting representing reality in the background of a city or landscape.

set – anywhere used as the background for a scene.

set up – the position of the camera in relation to the set and action during a single shot.

source light – a light motivated by a particular source ie a table lamp.

studio – a factory for the production of films, containing a number of stages and a back lot on which sets can be built and a tank where water scenes can be shot; as well as housing other relevant resources (production and art department offices, actors' dressing rooms, cutting rooms, equipment hire companies, visual effects companies, construction facilities and paint shops).

trompe l'oeil – painting effects designed to deceive the eye.

visual effects – any visual manipulation of the reality presented to the camera.

wild – an element of a set that can be removed to enable shooting lighting, for example a wall or ceiling.

FILMOGRAPHY

20,000 Leagues Under The Sea (Georges Méliès, 1907, Fr.)
2001: A Space Odyssey (Stanley Kubrick, 1968, US/UK)
24 Hour Party People (Michael Winterbottom, 2002, UK/Fr./Neth.)
About a Boy (Chris & Paul Weitz, 2002, UK)
A bout de souffle (Jean Luc-Godard, 1959, Fr.)
Absolute Beginners (Julian Temple, 1986, UK)
Aelita (Yakov Protazanov, 1924, USSR)
AI: Artificial Intelligence (Steven Spielberg, 2001, US)
Alice Doesn't Live Here Anymore (Martin Scorsese, 1974, US)
Alien (Ridley Scott, 1979, UK)
Alphaville (Jean Luc Godard, 1965, Fr./It.)
Amadeus (Milos Forman, 1984, US)
Amelie (Jean-Pierre Jeunet, 2001, Fr.)
An American in Paris (Vincente Minelli, 1951, US)
American Gigolo (Paul Schrader, 1980, US)
Angel Heart (Alan Parker, 1987, US)
Apartment, The (Billy Wilder, 1960, US)
Arrival of a Train at La Ciotat Station, The (Louis Lumière, 1895, Fr.)
A Trip to the Moon (Georges Méliès, 1902, Fr.)
Avengers, The (Jeremiah Chechik, 1998, US)
Barton Fink (Joel & Ethan Coen, 1991, US)
Basic Instinct (Paul Verhoeven, 1992, US)
Batman (Tim Burton, 1989, US)
Becky Sharp (Rouben Mamoulian, 1935, US)
Ben Hur (J.J. Cohn & Fred Niblo, 1925, US)
Ben-Hur (William Wyler, 1959, US)
Bicycle Thieves (Vittoria De Sica, 1948, It.)
Birds, The (Alfred Hitchcock, 1963, US)
Birth of a Nation (D.W. Griffiths, 1915, US)
Black Cat, The (Edgar G. Ulmer, 1934, US)
Black Narcissus (Michael Powell & Emeric Pressburger, 1947, UK)
Blade Runner (Ridley Scott, 1982, US)
Blair Witch Project (Daniel Myrick, Eduardo Sanchez II, 1999, US)
Blow Up (Michelangelo Antonioni, 1966, UK)
Blue Velvet (David Lynch, 1986, US)
Breakfast at Tiffany's (Blake Edwards, 1961, US)
Brighton Rock (John Boulting, 1947, UK)

Bwana Devil (Arch Oboler, 1952, US)
Cabinet of Dr Caligari, The (Robert Weine, 1919, Ger.)
Cabiria (Giovanni Patrone, 1914, It.)
Caravaggio (Derek Jarman, 1986, UK)
Carlito's Way (Brian De Palma, 1993, US)
Carnal Knowledge (Mike Nichols, 1971, US)
Casablanca (Michael Curtiz, 1942, US)
Cathy Come Home (Ken Loach, 1966, UK)
Cat People (Jacques Touneur, 1942, US)
Cavalcade (Frank Lloyd, 1934, US)
Chinatown (Roman Polanski, 1974, US)
Cimarron (Wesley Ruggles, 1931, US)
Citizen Kane (Orson Welles, 1941, US)
Civilization (Thomas Ince, 1916, US)
Cleopatra (Joseph L Mankiewicz, 1960, US)
Cook, the Thief, His Wife and Her Lover, The (Peter Greenaway, 1989, UK/Fr.)
Crowd, The (King Vidor, 1928, US)
Dante's Inferno (Henry Otto, 1924, US)
Days of Heaven (Terrence Malick, 1978, US)
Day of the Locust, The (John Schlesinger, 1975, US)
Dead End (William Wyler, 1937, US)
Deep Impact (Mimi Leder, 1998, US)
Dick Tracy (Warren Beatty, 1990, US)
Die Niebelungen (Fritz Lang, 1924, Ger.)
Die Strasse (Karl Grune, 1923, Ger.)
Diva (Jean-Jacques Beineix, 1981, Fr.)
Do the Right Thing (Spike Lee, 1989, US)
Don't Look Now (Nic Roeg, 1973, UK/It.)
Dove (Roland West, 1928, US)
Duel in the Sun (King Vidor, 1946, US)
East of Eden (Elia Kazan, 1955, US)
Edward II (Derek Jarman, 1991, UK)
Edward Scissorhands (Tim Burton, 1990, US)
Elephant Man, The (David Lynch, 1980, US)
Elizabeth (Shekhar Kapur, 1998, UK)
Empire Strikes Back, The (Irvin Kershner, 1980, US)
English Patient, The (Anthony Minghella, 1996, US)
Fatal Attraction (Adrian Lyne, 1987, US)
Flash Gordon (Mike Hodges, 1980, UK)
Forty Second Street (Lloyd Bacon, 1933, US)
Fountainhead, The (King Vidor, 1949, US)
Funny Lady (Herbert Ross, 1975, US)
Futureworld (Richard T Heffron, 1976, US)
Genuine (Robert Weine, 1920, Ger.)
Get Carter (Mike Hodges, 1971, UK)
Get Shorty (Barry Sonnenfeld, 1995, US)
Giant (George Stevens, 1956, US)
Gigi (Vincente Minnelli, 1958, US)
Godfather Trilogy, The (Francis Ford Coppola, 1971, 1974, 1990, US)
Golem (Paul Wegener, 1920, Ger.)
Gone With the Wind (Victor Fleming, 1939, US)
Gone To Earth (Michael Powell, Emeric Pressburger, 1950, UK)
Gosford Park (Robert Altman, 2002, UK)
Grand Hotel (Edmund Goulding, 1932, US)

Great Train Robbery, The (Edwin S. Porter, 1903, US)
Hamlet (Laurence Olivier, 1948, UK)
Harry and Tonto (Paul Mazursky, 1974, US)
Harry Potter and the Philosopher's Stone (Chris Columbus, 2001, US)
Harvey (Henry Koster, 1950, US)
Henry V (Laurence Olivier, 1944, UK)
His Girl Friday (Howard Hawks, 1940, US)
Honey, I Shrunk The Kids (Joe Johnston, 1989, US)
Hotel (Mike Figgis, 2001, UK/It.)
How Green Was My Valley (John Ford, 1941, US)
How To Marry A Millionaire (Jean Negulesco, 1953, US)
Hudsucker Proxy, The (Joel & Ethan Coen, 1994, US)
Hustler, The (Rob Rossen, 1961, US)
Indecent Proposal (Adrian Lyne, 1993, US)
Independence Day (Roland Emmerich, 1996, US)
Intolerance (D.W. Griffith, 1916, US)
It Always Rains on Sundays (Robert Hamer, 1947, UK)
Journey to the Moon (George Méliès, 1902, Fr.)
Jubilee (Derek Jarman, 1978, UK)
Jude (Michael Winterbottom, 1996, UK)
Jurassic Park (Steven Spielberg, 1993, US)
Kind Hearts and Coronets (Robert Hamer, 1949, UK)
King and I, The (Walter Lang, 1956, US)
King Kong (Merian C Cooper, 1933, US)
La Dolce Vita (Federico Fellini, 1960, It./Fr.)
Ladykillers, The (Alexander Mackendrick, 1955, UK)
Last Tango in Paris (Bernardo Bertolucci, 1972, It./Fr.)
Legend (Ridley Scott, 1985, US)
Léon (Luc Besson, 1994, Fr./US)
Life Less Ordinary, A (Danny Boyle, 1997, UK)
L'Inhumaine (Marcel L'Herbier, 1924, Fr.)
Lock Stock and Two Smoking Barrels (Guy Ritchie, 1998, UK)
Long Day Closes, The (Terence Davies, 1992, UK)
Lost Horizon (Frank Capra, 1937, US)
Mad Max (George Miller, 1979, Aust.)
Male and Female (Cecil B. DeMille, 1919, US)
Manproof (Richard Thorpe, 1938, US)
Matrix, The (Andy Wachowski, Larry Wachowski, 1999, US)
Matter of Life and Death, A (Michael Powell & Emeric Pressburger, 1946, UK)
Meet Me in St Louis (Vincente Minnelli, 1944, US)
Metropolis (Fritz Lang, 1926, Ger.)
Money Pit, The (Richard Benjamin, 1985, US)
Monte Carlo (Ernst Lubitsch, 1930, US)
Moulin Rouge (Baz Luhmann, 2001, Aus.)
My Beautiful Launderette (Stephen Frears, 1985, UK)
New York, New York (Martin Scosese, 1977, US)
Nil By Mouth (Gary Oldman, 1998, UK)
Notting Hill (Roger Michell, 1999, UK)
Once Upon a Time in the West (Sergio Leone, 1968, It.)
On The Town (Stanley Donen, 1949, US)
On The Waterfront (Elia Kazan, 1954, US)
Our Dancing Daughters (Harry Beaumont, 1928, US)
Pennies From Heaven (Herbert Ross, 1981, US)
Player, The (Robert Altman, 1992, US)

Playtime (Jacques Tati, 1967, Fr.)
Project X (Jonathan Kaplan, 1987, US)
Prospero's Books (Peter Greenaway, 1991, Fr./ Jap./It./Neth./UK)
Psycho (Alfred Hitchcock, 1960, US)
Quo Vadis (Enrico Guazzoni, 1912, It.)
Raiders of the Lost Ark (Steven Spielberg, 1981, US)
Rear Window (Alfred Hitchcock, 1954, US)
Rebecca (Alfred Hitchcock, 1940, US)
Red Desert, The (Michelangelo Antonioni, 1964, It./Fr.)
Red Shoes, The (Powell & Pressburger, 1948, UK)
Remains of the Day, The (Merchant & Ivory, 1993, UK)
Reservoir Dogs (Quentin Tarantino, 1991, US)
Robin Hood (Allan Dwan, 1922, US)
Room with a View, A (James Ivory, 1986, UK)
Rope (Alfred Hitchcock, 1948, US)
Rumble Fish (Francis ford Coppola, 1983, US)
Samson and Delilah (Cecil B. DeMille, 1949, US)
Saturday Night Fever (John Badham, 1977, US)
Scarface (Brian De Palma, 1983, US)
Servant, The (Joseph Losey, 1963, UK)
Sense and Sensibility (Ang Lee, 1996, US/UK)
Shakespeare In Love (John Madden, 1998, US/UK)
Shallow Grave (Danny Boyle, 1994, UK)
Shampoo (Hal Ashby, 1975, US)
Sheltering Sky, The (Bernardo Bertolucci, 1990, UK/It.)
Shining, The (Stanley Kubrick, 1980, US)
Star Is Born, A (William Wellman, 1937, US)
Starship Troopers (Paul Verhoeven, 1997, US)
Star Wars (George Lucas, 1977, US)
Star Wars: Episode One – The Phantom Menace (George Lucas, 1999, US)
Star Wars: Attack of the Clones (George Lucas, 2001, US)
Stormy Monday (Mike Figgis, 1987, UK)
Street Scene (King Vidor, 1931, US)
Strictly Ballroom (Baz Luhrmann, 1992, Aus.)
Suddenly Last Summer (Joseph L. Mankiewicz, 1959, US)
Tempest, The (Sam Taylor, 1928, US)
Ten Commandments, The (Cecil B. DeMille, 1923, US)
Terminator, The (James Cameron, 1984, US)
Terminator 2: Judgment Day (James Cameron, 1991, US)
Thief of Baghdad, The (Raoul Walsh, 1924, US)
Things To Come (William Cameron Menzies, 1936, US)
Tombraider (Simon West, 2001, US)
Toy Story (John Lasseter, 1996, US)
Trainspotting (Danny Boyle, 1996, UK)
Tron (Steven Lisberger, 1982, US)
Trouble in Paradise (Ernst Lubitsch, 1932, US)
U Turn (Oliver Stone, 1997, US)
Velvet Goldmine (Todd Haynes, 1998, UK/US)
Vertigo (Alfred Hitchcock, 1958, US)
Vidocq (Pitof, 2001, Fr.)
Wall Street (Oliver Stone, 1987, US)
Way Down East (D.W. Griffith, 1920, US)
Way We Were, The (Sydney Pollack, 1973, US)
West Side Story (Robert Wise/Jerome Robbins, 1961, US)

Westworld (Michael Crichton, 1973, US)
Whisky Galore! (Alexander Mackendrick, 1948, UK)
Withnail & I (Bruce Robinson, 1987, UK)
Wizard of Oz, The (Victor Fleming, 1939, US)
Working Girl (Mike Nichols, 1988, US)
Zoolander (Ben Stiller, 2001, US/Aus./Ger.)

TELEVISION

Ally McBeal (David E Kelley, 1997–, US)
Avengers, The (Sydney Newman, 1961–69, UK)
Brideshead Revisited (Michael Lindsay Hogg, Charles Sturridge, 1981, UK)
Cheers (James Burrows, Glen Charles, Les Charles, 1982–93, US)
Cold Lazarus (Renny Rye, 1996, UK)
Cosby Show, The (Bill Cosby, 1984–92, US)
Dr Who (Sydney Newman, 1963–89, UK)
EastEnders (Jeremy Ancock, David Andrews, 1985–, UK)
Frasier (David Angell, David Lee, 1993–, US)
Friends (David Crane, Marta Kauffman, 1994–, US)
Gormenghast (Andy Wilson, 2000, UK/US/Can.)
Hammer House of Hòrror (Tom Clegg, Alan Gibson, 1980, UK)
Miami Vice (Anthony Yerkovich, 1984–89, US)
Pop Idol (Simon Fuller, 2001–, UK)
Roseanne (Ellen Falcon, 1988–97, US)
Sex and the City (Darren Star, 1998–, US)
Singing Detective, The (Jon Amiel, 1986, UK/Aus.)
Vanity Fair (Marc Munden, 1999, UK/US)
This Morning (1998–, UK)
Weakest Link, The (Frintan Coyle, 2000–, UK)
Who Wants to be a Millionaire (Jonathan Bullen, 1998–, UK)

BIBLIOGRAPHY

The bibliography lists works cited in the text and is also designed to point to useful further reading. The 'essential reading' list highlights works considered to be of particular importance to the understanding of production design, although many valuable contributions are also to be found under 'secondary reading'.

ESSENTIAL READING

Affron, Charles & Mirella Jona (1995) *Sets in Motion: Art Direction and Film Narrative*. New Brunswick: Rutgers University Press.

Albrecht, Donald (1986) *Designing Dreams*. New York: Harper & Row.

Barsacq, Leon (1976) *Caligari's Cabinet and Other Grand Illusions: A History of Film Design*. Boston: New York Graphic Society.

Berger, John (1972) *Ways of Seeing*. London: BBC & Penguin Books.

Byrne, Terry (1993) *Production Design for Television*. USA: Butterworth-Heinemannn.

Carrick, Edward (1948) *Art and Design in the British Film*. London: Dennis Dobson.

Clarens, Carlos & Mary Corliss (1978) 'Designed for Film: The Hollywood Art Director', *Film Comment*, 14, 3.

Eisner, Lotte H. (1973) *The Haunted Screen. Expressionism in the German Cinema and the Influence of Max Reinhardt*. London: Secker & Warburg.

Ettedgui, Peter (ed.) (1999) *Production Design & Art Direction*. Switzerland: Screencraft.

Heisner, Beverly (1990) *Hollywood Art: Art Direction in the Days of the Great Studios*. London: Mcfarland.

____ (1997) *Production Design in the Contemporary American Film*. North Carolina: McFarland.

LoBrutto, Vincent (1992) *By Design: Interview with Film Production Designers*. London: Praeger.

Ludi, Heidi (2000) *Movie Worlds: Production Design in Film*. Stuttgart: Menges.

Mallet-Stevens, Robert (1927) *L'Art cinematographique*. Paris: Felix Alcan.

Mandelbaum, Howard (1985) *Screen Deco: A Celebration of High Style in Hollywood*. New York: St Martin's Press.

Millerson, Gerald (1989) *TV Scenic Design Handbook*. London & Boston: Focal Press.

Neumann, Dietrich (1997) *Film Architecture from Metropolis to Blade Runner*. Munich: Prestel.

Olson, Robert (1993) *Art Direction For Film and Video*. Boston & London: Focal Press.

Sennet, Robert S. (1994) *Setting the Scene: The Great Hollywood Art Directors*. New York: Harry N. Abrams.

Sylvester, David (2000) *Moonraker, Strangelove and Other Celluloid Dreams: The Visionary*

Art of Ken Adam. London: Serpentine Gallery.
Tashiro, Charles Shiro (1998) *Pretty Pictures: Production Design and the History Film*. Texas: University of Texas Press.

SECONDARY READING

Anon. (1979) 'The Art of Art Direction', *Focus on Film*, 34, 19–20.
____ (1982) 'The State of The Art', *Cinema Papers*, 37, 143–6, 183.
____ (1985) 'They Call it Production Design', *American Film*, 11, 3, 12–16.
____ (1999) 'The House That Hammer Built', *American Film*, 11, 3, 137–76.
Allen, Michael (1998) 'From Bwana Devil to Batman Forever: Technology in Contemporary Hollywood Cinema', in Steve Neale & Murray Smith (eds) *Contemporary Hollywood Cinema*. London: Routledge, 123–4.
Andrews, Nigel (1985) 'Art is a Matter of Lying a Little', *Listener*, 114, 2920, 13–14.
Bancroft, Shelly (1986) 'Set Pieces: The work of designer Asheton Gorton', AIP, 71, 16–20.
Barr, Charles (1986) *All Our Yesterdays*. London: BFI
____ (1998) *Ealing Studios*. Berkeley: University of California Press.
Barnett, Casey (1988/89) 'Shooting the Period Picture on Location: An Interview with Joe Alves', *American Premiere*, 8, 6, 25–9.
Braester, Yomi (2002) 'Memory, History on screen', *Screen*, 42, 4, 350–62.
Brandt, George W. (1993) *British Television Drama in the 80s*. Cambridge: Cambridge University Press.
Brownlow, Kevin (1968) *The Parade's Gone By*. New York: Alfred A. Knopf.
Brunsdon, Charlotte (1999) 'Space in the British Crime Film' in Steve Chibnall & Robert Murphy (eds) *British Crime Cinema*. London: Routledge, 148–59.
Butler, Justine, Louise McElvogue & Mary Anne Reid (1988) 'You're only as good as your last job.' *Encore*, 5, 23, 23–32.
Chibnall, Steve (1999) 'Ordinary People: New Wave Realism and the British Crime Film 1959–1963', in Steve Chibnall & Robert Murphy (eds) (1999) *British Crime Cinema*. London: Routledge, 94–109.
Chibnall, Steve & Robert Murphy (eds) (1999) *British Crime Cinema*. London: Routledge.
Christopher, Roy (1989) 'How to Stretch Budget Bucks', *Hollywood Reporter*, 306, 36, 32.
Church Gibson, Pamela (2000) 'Fewer Weddings and More Funerals: Changes in the Heritage Film', in Robert Murphy (ed.) *British Cinema of the 90s*. London: BFI, 121.
Clarens, Carlos & Mary Corliss (1986) 'The Pit and the Production Designer', *Film Comment*, 22, 2, 4 & 72.
Clarke, David B. (1997) *The Cinematic City*. London: Routledge.
Cook, Pam (1985) *The Cinema Book*. London: BFI.
Day, Marc O. (2001) 'Of Leather Suits and Kinky Boots: *The Avengers*, Style and Popular Culture', in Anna Gough-Yates & Bill Osgerby (eds) *Action TV: Tough Guys, Smooth Operators & Foxy Chicks*. London: Routledge, 232.
Deegan, Clodagh (1999) 'A Map of The Art', *Film West*, 36, 46–8.
Deschner, Donald (1978) 'Interview with Edward Carfagno, MGM Art Director', *Velvet Light Trap*, 18, 30–4.
Dowding, Jon (1982) 'The Production Designer', *Cinema Papers*, 36, 27–30.
Driver, Martha (1999) 'Writing about Medieval Movies: Authenticity and History', *Film and History*, 29, 1/2, 5.
Durgnat, Raymond (1983) 'Art for Film's Sake', *American Film*, 8, 7, 41–45.
Eberle, Ed (1997) '"State of the Art": Art Directors Discuss the Medium of Music Video', *Film & Video*, 13, 10, 31–32 & 106.
Elsaesser, Thomas. (1994) *Early Cinema: Space, Frame, Narrative*. London: BFI.
Everett, James (1999) 'Highest Tribute', *Film and History*, 29, 1/2, 84–5.
Ferguson, Ken (1980) 'The Art of Hollywood.' *Photoplay*, 31, 2, 26–9.
Field, Alice Evans (1952) 'The Art Director's Art', *Films in Review*, 3, 2, 60.

Field, Eunice (1980) 'Art Director: businessman, diplomat, dreamer', *Hollywood Reporter*, 260, 50, 33.

Foley, Kathleen F. (1989) 'The 65th Anniversary of the Society of Motion Picture & Television Art Directors', *Hollywood Reporter*, 306, 36, S1–S54.

Gavenas, Maria Lisa (1989) 'Art Directors' Influence on America', *Hollywood Reporter*, 306, 36, 24.

Gibbs, John (2002) *Mise-en-scène: Film Style and Interpretation*. London: Wallflower Press.

Gough-Yates, Anna & Bill Osgerby (2001) *Action TV: Tough Guys, Smooth Operators and Foxy Chicks*. London: Routledge.

Hauffe, Thomas (1998) *Design: A Concise History*. London: Laurence King.

Herzfeld, Jill (1986) 'Joe Jennings', *On Location*, 9, 11, 162–3.

Hill, John (1999) *British Cinema in the 1980s*. Oxford: Oxford University Press.

Hope, Ted & Scott Macaulay (1994) 'The Draughtsman's Contract', *Filmmaker*, 2, 3, 32–3, 59.

Horner, Harry (1977) 'The Greystone Seminar', *American Film*, 2, 4, 33–4.

Isaacs, J. (1950) 'The Visual Impact', *Sight and Sound*, 19, 2. 80–1.

James, Nick (1997) 'Being there: Interview with Hugo Luczyc-Wyhowski', *Sight and Sound*, 7, 10, 6–9.

Jones, Alan (1989) 'Designing *The Legend*', *Cinefantastique*, 20, 1/2, 58.

Keane, Stephen (2001) *Disaster Movies: The Cinema of Catastrophe*. London: Wallflower Press.

King, Geoff (2000) *Spectacular Narratives: Hollywood in the Age of the Blockbuster*. London: I. B. Tauris.

King, Geoff & Tanya Krywinska (2000) *Science Fiction Cinema: From Outerscape to Cyberspace*. London: Wallflower Press.

Kobal, John (1973) *Gotta Sing Gotta Dance: A Pictorial History of Film Musicals*. London: Hamlyn.

Kuter, Kay E. (1977) 'Art That Disguises Art', *American Film*, 2, 7, 5.

Kuter, Leo K. (1957) 'Art Direction is an Important and Little Understood Component of a Movie', *Films In Review*, 8, 6, 248–58.

Lay, Samantha (2002) *British Social Realism: From Documentary to Brit-Grit*. London: Wallflower Press.

Lury, Karen (2000) 'Here and Then: Space, Place and Nostalgia in British Youth Cinema of the 90s', in Robert Murphy (ed.) *British Cinema of the 90s*. London: BFI, 106.

Macnab, Geoffrey (2002) 'Review of *Hotel*', *Sight and Sound*, 12, 5, 46.

Marner, John Terrence (1974) *Film Design*. London: Tantivy Press.

McDonald, Paul (2000) *The Star System: Hollywood's Production of Popular Identities*. London: Wallflower Press.

Millar, Simon (1994) 'Portraits of the Artists', *Filmmaker*, 2, 3 34–6.

Mills, Bart (1982) 'The Brave New Worlds of Production Design', *American Film*, 7, 4, 40–6.

Monaco, James (1977) *How to Read a Film: The Art, Technology, Language, History and Theory of Film and Media*. New York, Oxford: Oxford University Press.

Morahan, M. J. (1951a) 'Modern Trends in Art Direction', *British Kinematography*, 18, 3, 76–82.

____ (1951b) 'Trends in Art Direction', *The Cine Technician*, 17, 91, 108–13, 117.

Murphy, Robert (2000) *British Cinema of the 1990s*. London: BFI.

Neale, Steve & Murray Smith (1998) *Contemporary Hollywood Cinema*. London: Routledge.

Newberry, Norm (1989) 'Theme Parks Bring Art to Life', *Hollywood Reporter*, 306, 36, 36.

Orpen, Valerie (2003) *Film Editing: The Art of the Expressive*. London: Wallflower Press.

Pandiscio, Richard (1995) 'Ones To Watch', *Interview*, 25, 12, 32.

Peachment, Chris (1979) 'Review of the *Art of Hollywood* Exhibition at the Victoria & Albert Museum', *Time Out*, 14 December, 49.

Petrie, Duncan (1996) *Inside Stories: Diaries of British Film-makers at Work*. London: BFI.

Rosenstone, Robert A. (1996) *Visions of the Past*. Massachusetts: Harvard University Press.

Rotha, Paul (1928) 'Artists Behind the Film Technique of the Art Director', *Film Weekly*, 1, 4, 16.

Schweiger, Daniel (1991) '*Rocketeer*: Production Design', *Cinefantastique*, 22, 1, 29.

Stein, Elliot (1975) 'The Art of Art Direction', *Film Comment*, 11, 3, 32–4.

Strick, Philip (1983) 'Studio Art', *Stills*, 9, 68–70.

Sylbert, Richard (1989) 'Production designer is his title. Creating realities is his job' (feature on Richard Sylbert), *American Film*, 15, 3, 22–6.

Thompson, Andrew O. (1997) 'How the Southwest was redone', *American Cinematographer*, 78, 10, 37–8.

Thomson, David (1977) 'The Art of the Art Director', *American Film*, 2, 4, 12–20.

Turner, Geoff (1987) 'High Tech Look for Project X', *American Cinematographer*, 68, 6, 56–9.

Wells, Paul (2000) *The Horror Genre: From Beelzebub to Blair Witch*. London: Wallflower Press.

White, Roland (2002) 'So nice to see you', *Sunday Times*, 12.

Williams, Zoe (2002) 'Hugh Are You Trying To Kid?', *Weekend Guardian*, 27 April, 69.

Wollen, Peter (1998) *Signs and Meaning in the Cinema*. London: BFI.

Zaidi, Shama (1991) 'Design In Indian cinema' *Cinema In India*, 2, 2, 28–33.